for Lisa Michelle King

Our memory of you, unlike a photograph, shall not fade

AUSTRALIA
Facing the South

All of the David Evans images in this book are available as
exhibition quality Limited Edition prints through

australiangallery.com

photography by
DAVID EVANS

poetry by
JENNIE SHARPE
music soundtrack by
LEAH CURTIS

A U S T R A L I A
Facing the South

David Evans, Jennie Sharpe, Leah Curtis

First published in 2004 by

australian gallery publishing ©
(www.australiangallerypublishing.com)

DAVID EVANS ©
PHOTOGRAPHY
PO Box 271
Stepney
South Australia 5069
Ph: +61 8 8331 1468
Fax: +61 8 8331 1462
ABN: 48 314 982 488

australiangallery.com ©
(info@australiangallery.com)

Design by Felicity Gladwin (Ausgal Design) and David Evans

ausgal design ©
(www.ausgaldesign.com)

Published in Australia. Colour separations by Colorwize Studio, Adelaide. Printing, binding and CD replication by
Everbest Printing Co., China. Australian music composed, orchestrated and produced by Leah Curtis. Recorded in Prague,
Czech Republic with full Prague Studio Symphony Orchestra. Conducted by Adam Klemens. Mixed and mastered at
Private Island Trax Studios, Hollywood, USA. 'Pure Nature Recordings' from Listening Earth, Castlemaine, Australia.

The National Library of Australia Cataloguing-in-Publication entry;

Evans, David H.
 Australia : facing the south.

 Includes index.
 ISBN 0 646 43180 3.

 1. Australia - Pictorial works. 2. Australian poetry
 3. Australia - Songs and music.
 I. Sharpe, Jenny E. II. Curtis, Leah M. III. Title.

770.994

Contents

Acknowledgments

David Evans would like to thank:

Leah Curtis, composer (www.leahcurtis.com)
Jennie Sharpe, poet/writer
Ian Carlson, photographer (www.australiangallery.com)
Felicity Gladwin, designer (www.ausgaldesign.com)
Lyndal Stuart, publicist
Andrew Skeoch & Sarah Koschak, pure nature recordings
(www.listeningearth.com.au)
Meaghan Aldridge, computer consultant (www.clickthis.net.au)
Tony Witcher, Paul Aikman & Warren Ashton, Colorwize Studio
Lionel Marz, Everbest Printing
Peter Nicholson, Watermark Publishing
Alice Lay
Emily Garth
Jennifer Ross
Julie Evans
Katherine Randall
Gary Graham, Photographer
Christian Wright, Photographer
Benjamin Lai
Karen Billington
Nikki Bray
Reinette Black & 'Big Tom'
The South Australian Tourism Commission
Kathmandu
CFL Print Studio
Art Essentials
Icon Communications
Colourchrome Laboratories
The B&W Lab
Vision Graphics
The Lab
…and countless others

David Evans would also like to thank
the following sponsors:

Jennie Sharpe would like to thank:

Katie Sharpe
Kathy Burleigh

Leah Curtis would like to thank:

Damien Perriman
Bede Curtis
Lauraine Curtis
Katrina Spence
Nicholas Spence
Michelle Curtis
Alastair Phillips
The exceptional musicians from the Prague Studio Symphony
Orchestra, the engineers and scoring support staff
Adam Klemens, conductor

This project has been assisted by the Commonwealth Government
through the Australia Council, its arts funding and advisory body.

Introduction

Australia is a continent which stimulates the senses like no other. In this book, Australian photographer David Evans captures the colour, contrast and movement of this ancient and largely uninhabited land of the south.

Australia: Facing the South is the culmination of five years exploration and discovery in the southeastern states of Australia, the images crafted from patience, dedication and a little bit of luck in a bold and spectacular style. This region includes New South Wales, Victoria, Tasmania and South Australia, and is below 30 degrees south in latitude. It is the most populated on the continent, and yet by world standards is uncrowded. These photographs are just some of David's favourite places and demonstrate that despite this relatively high population, landscapes and wilderness areas of great beauty exist in abundance.

Complementing the superb photography, Australian poet Jennie Sharpe has written original poetry for many of the images. Jennie's work provides another layer to the photographs, creating an absorbing visual <u>and</u> literary experience. The emotion and the stories told evoke moods and perception only limited by the imagination.

To complete the experience, a stunning music soundtrack has been composed and compiled on CD, consisting of an original Australian symphony. Music from award-winning composer Leah Curtis, played by some of the world's best studio musicians, features on this fine example of Australian musical talent. The soundtrack enhances the essence of the Australian landscape as seen through the eyes and camera lens of David Evans, and the writing of Jennie Sharpe. The soundtrack also features 'pure nature recordings' from Listening Earth between movements, further transporting the listener into the Australian landscape.

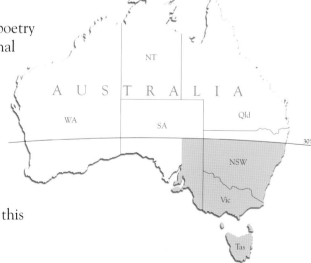

This unique combination of all-Australian photography, poetry and music is a journey for the senses, reflecting the personal and intimate experience of nature in more than just a visual way. To do justice to the vast open spaces and natural wonders of this country is an ominous task, but one that has been undertaken superbly by David Evans and these brilliant artists. This is an outstanding showcase of not only the landscape of Australia, but also its creative inhabitants.

Join these artists and the rest of the world, as we marvel at this continent in *Australia: Facing the South.*

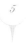

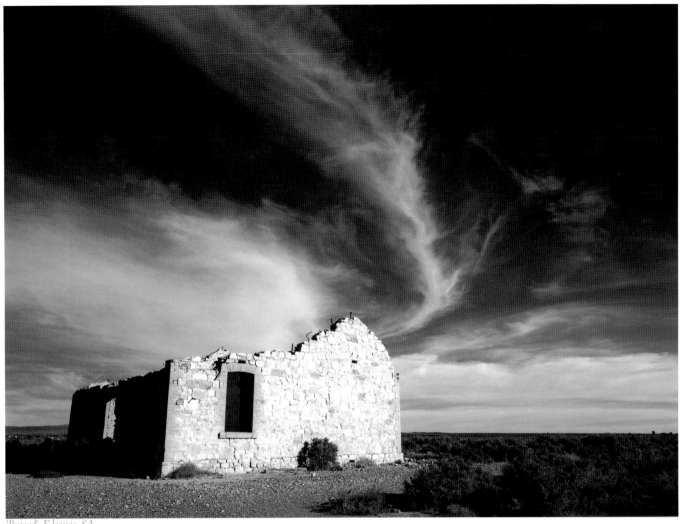

'Ruined', Edeowie, SA

Ruined

Let go its spirits, upon the outward breath, the house decays, leaving its shell like age-old
flowers dried in a wreath, creating its own grave.

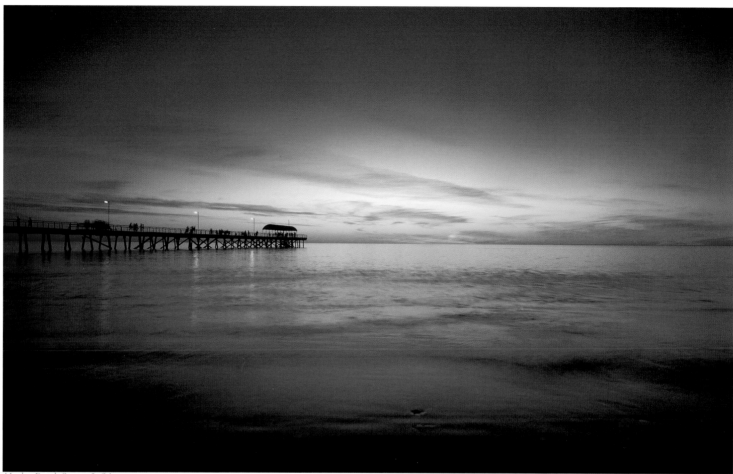

Henley Beach Sunset 2, SA

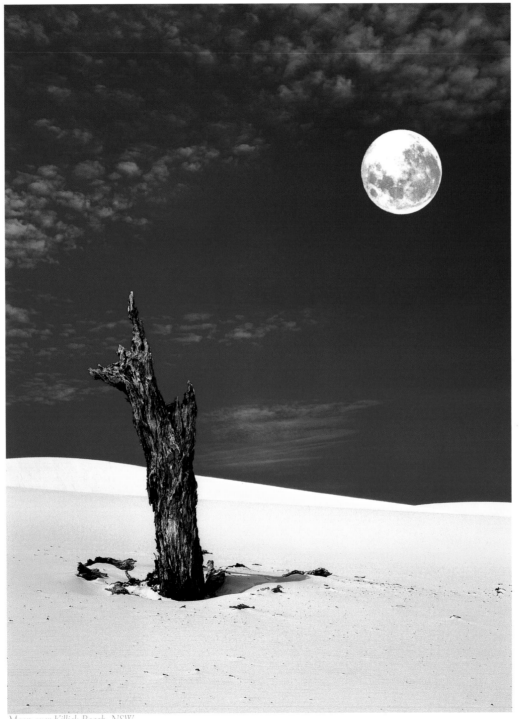

Moon over Killick Beach, NSW

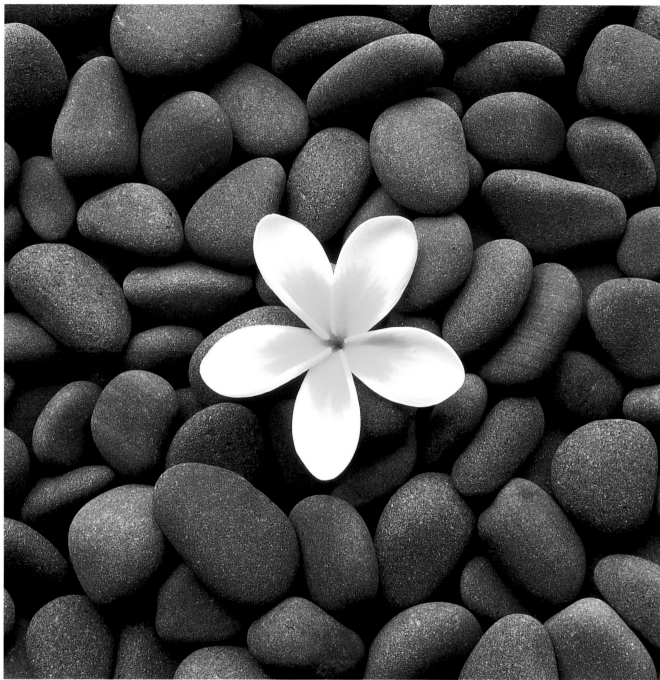

Frangipani, North Coast NSW

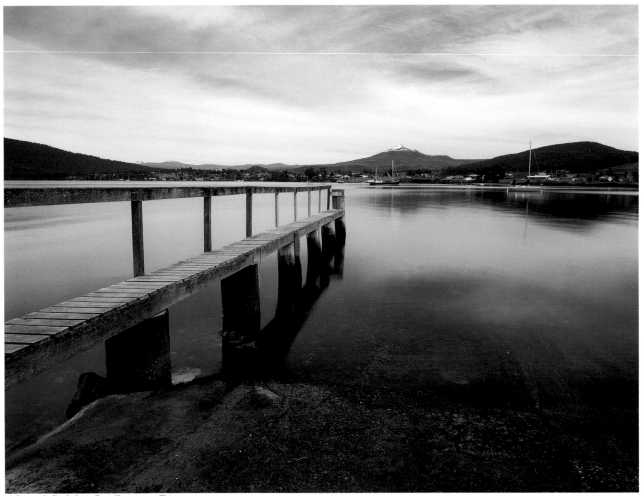

Adamson's Peak from Port Esperance, Tas

Adamson's Peak

So soft I came walking here at Port Esperance,
Looking out to Adamson's
And skimming a few stones
I collected along the path.
Little passing footfalls
And the water still as ice
When I stood in a white dress
At the end of the boards

And stared down to the depths;
Watched the sky slowly lighting candles
In the West
And, thinking nothing thoughts
Nether the winds,
Time passed slowly as the little golden wheel
That spins by untouched fingers
'Neath the clouds.

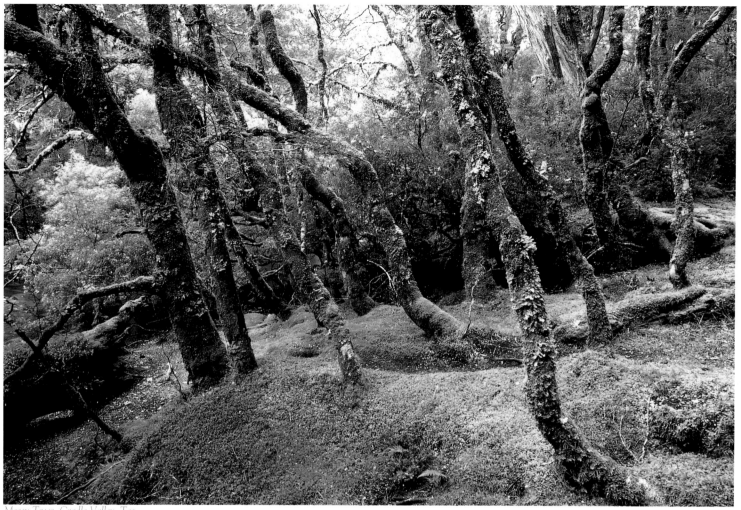

Mossy Trees, Cradle Valley, Tas

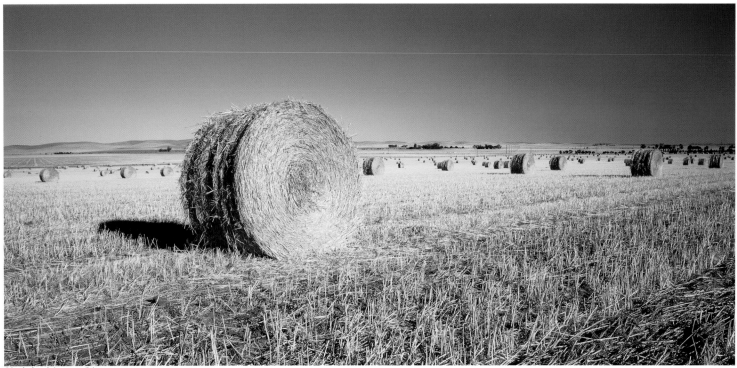

Haybales, Mintaro, SA

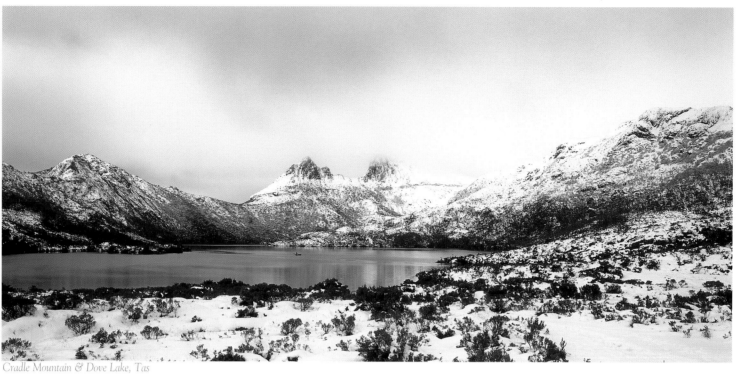

Cradle Mountain & Dove Lake, Tas

Cradle Mountain and Dove Lake

One arm extends outwards,
The other encloses,
Piece by piece
The layer
Freezes
And
In blue
And white
The oceanic
Mountain ranges
Prepare themselves
For the onslaught of the winds.

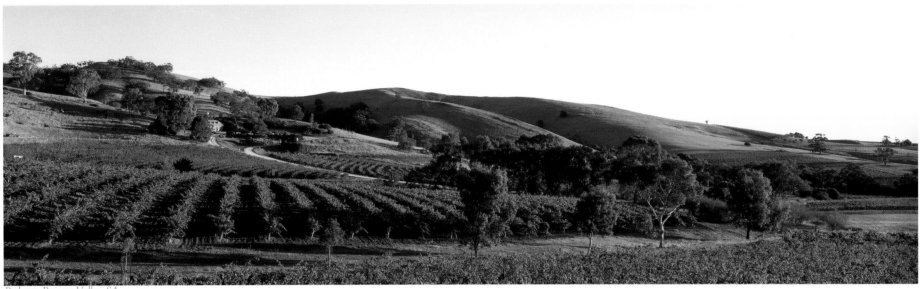

Bethany, Barossa Valley, SA

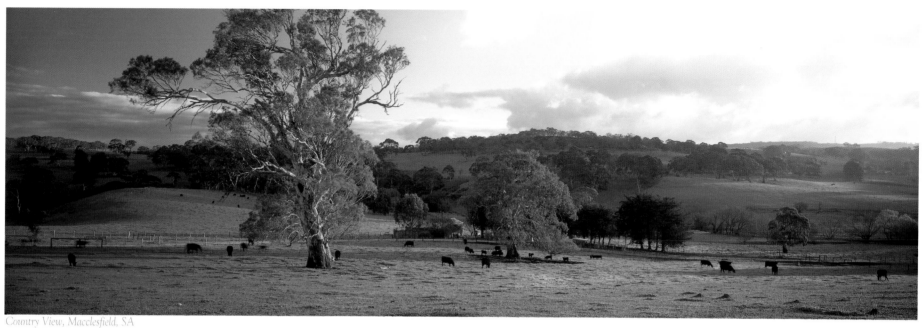

Country View, Macclesfield, SA

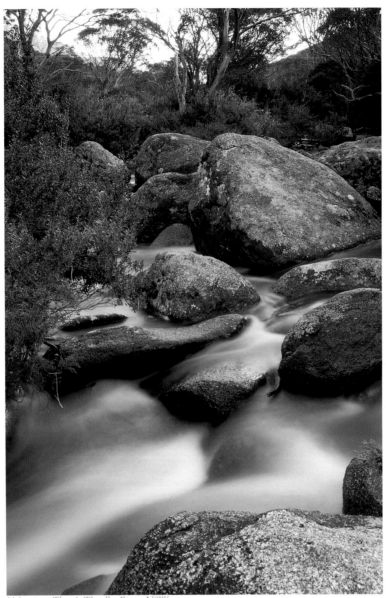

'Afternoon Thaw', Thredbo River, NSW

Afternoon Thaw

The trees oversee you, waters, as you cascade in the dying voices of the night.
There is stardust in your lashes, trapped under the rocks.
Keep silence and float your peace outwards:
There we have left our carry bags, awaiting your fingers to stray and find us.
Bathe the feet of the wanderers of the earth.

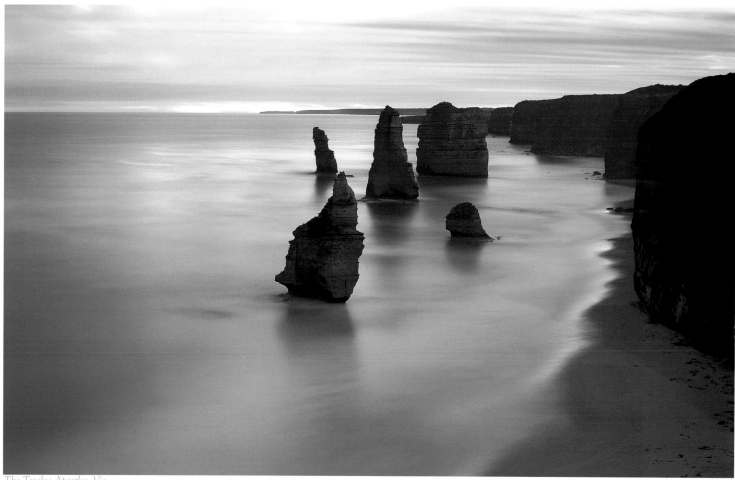

The Twelve Apostles, Vic

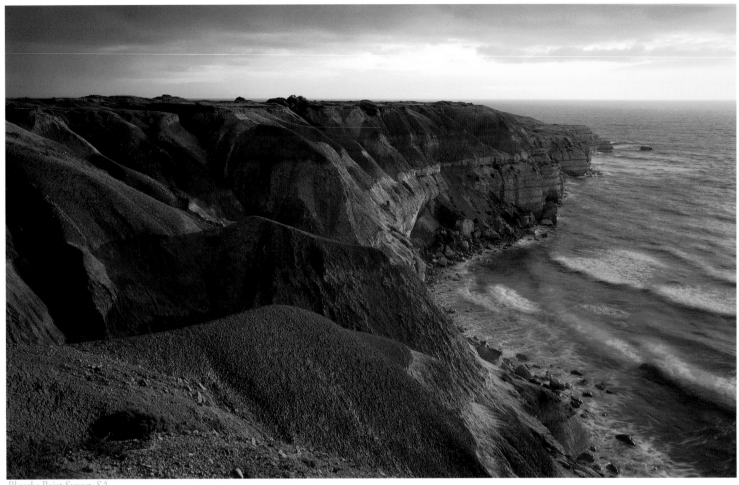

Blanche Point Sunset, SA

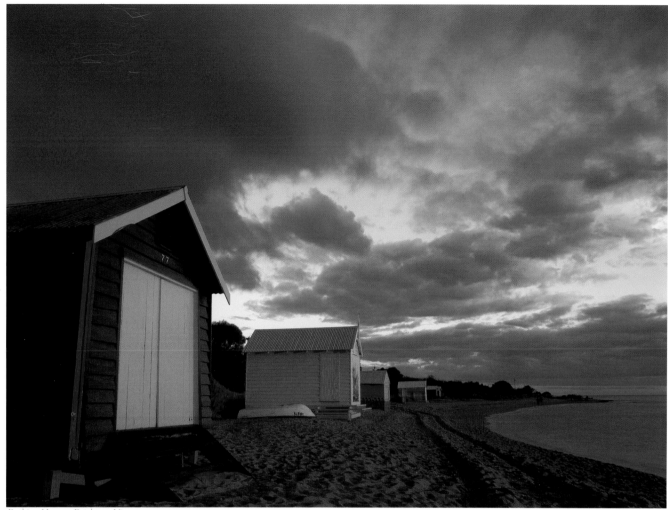

Bathing Huts at Brighton, Vic

Bathing Huts at Brighton

"Darling!
I have come with my pink scarf on!"
There were parties with jewel beads
And she scattered powder dust
Over her nose.
Thin thighs, wide thighs,
The clasps of swimming costumes
Round the legs
Gave off a shimmer
Danced their legs

Upwards
Right through the hole in the clouds.
Puissant faeries
Reading romance novels
Spread out on towels.
Brightly coloured bathing caps
Splashed and pashed
Secretly
In the bathing huts
At Brighton.

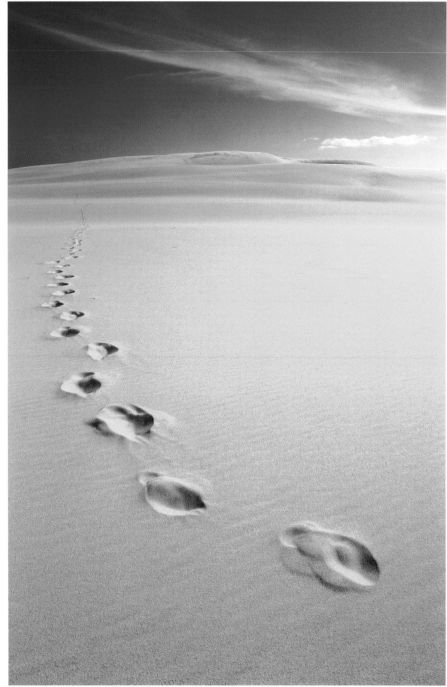

Footprints, North Coast NSW

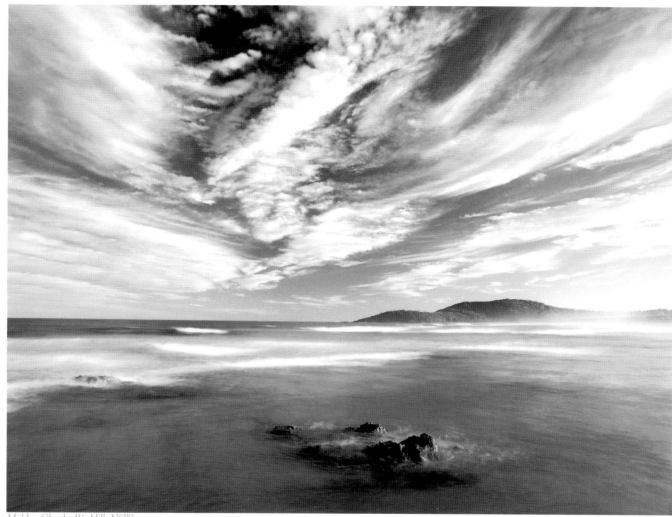

Midday Clouds, Big Hill, NSW

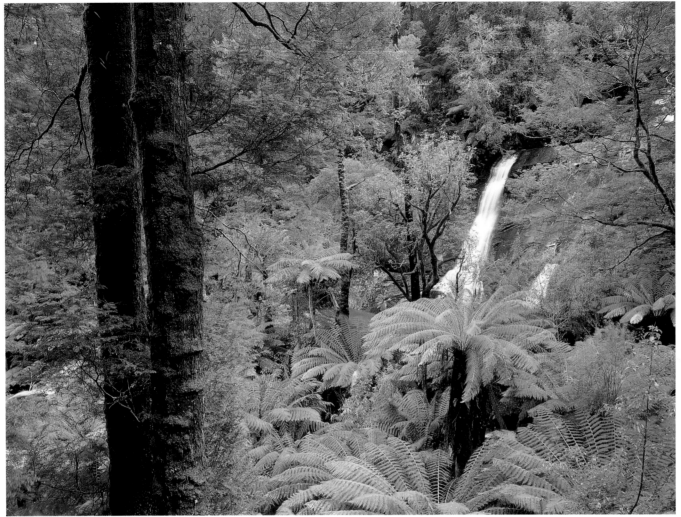

Triplet Falls, Otway Ranges, Vic

Triplet Falls

I lay out in the ferns, became each tiny leaf, was lengthened to a breath in the bark and,
where the waterfall sings, there I fell in droplets, raining showers;
I was immersed, forgotten, etherised by time.

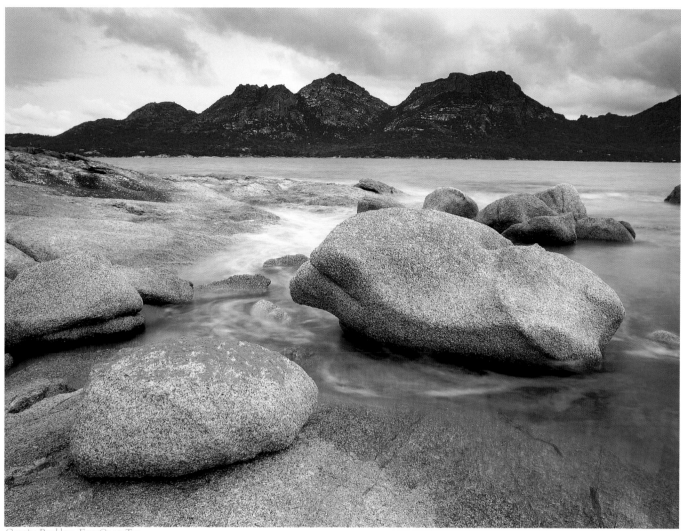

Granite Boulders, East Coast Tas

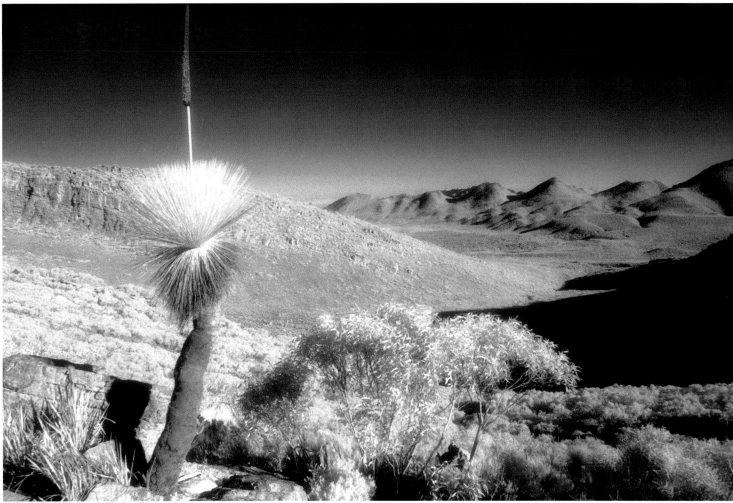

Wilpena Pound Infrared, Flinders Ranges, SA

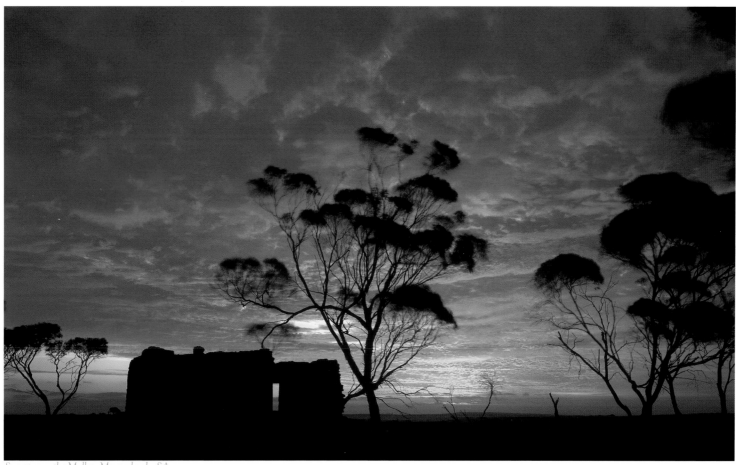

Sunset over the Mallee, Murraylands, SA

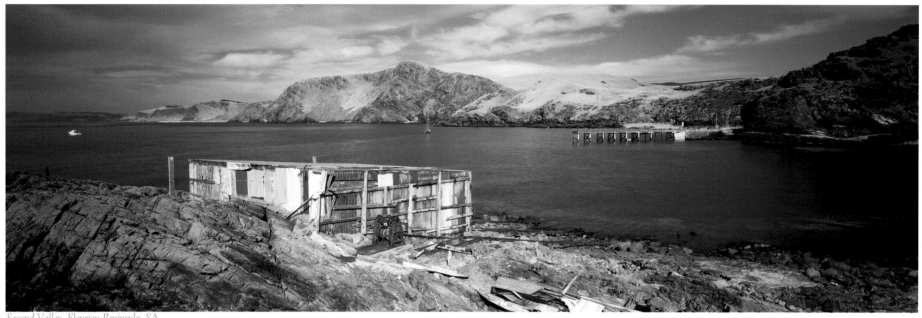

Second Valley, Fleurieu Peninsula, SA

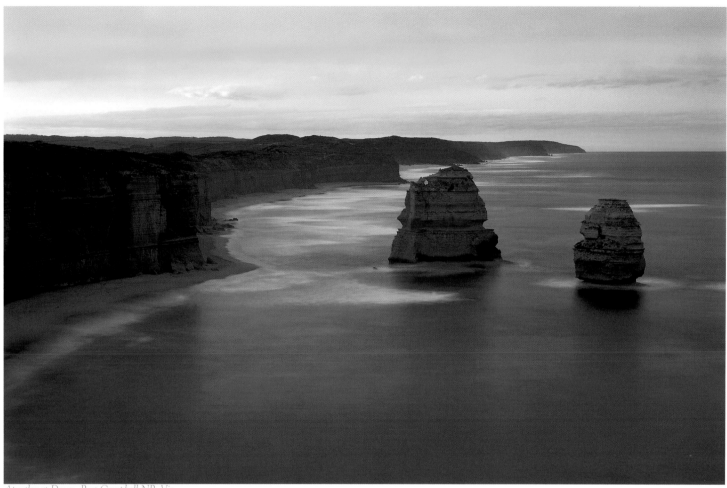

Apostles at Dawn, Port Campbell NP, Vic

Apostles at Dawn

A fierce wind first
Then
A shout and the waves break upwards
Into your hair and eyes.
When all clears
There grows the awareness -
First your eyes then your hands sweep the body and curve of this inlet.

When you step out to take your place as the rock's spirit
Be sure to gently note the colour of its stone
And melt your own skin like silver…
But you are all mercurial and run across the flesh of this apostle,
Dance into the waves
And then upwards
Into this sunrise.

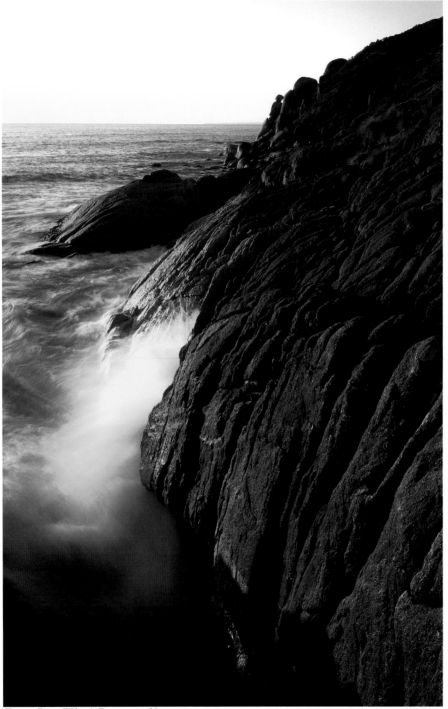

Tongue Point, Wilson's Promontory, Vic

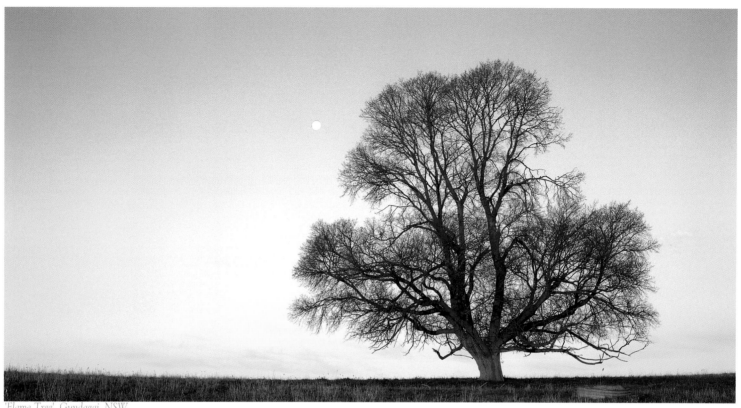

'Flame Tree', Gundagai, NSW

House of the Sunland (Burra Homestead)

They built you in the sunland,
They built you on an earth that had no light
Yet all the warmth and pallor of the heat.
They walked these hills,
Setting out with hands in pockets
They trod their lonely thoughts into the dust.
And you sat
And you watched.

Were you not wise, full of those eternal wisdoms
That simple things
Hide within their cavities?
We see the black shadows where the ribcage
Of your heart hides mysteries
Of things not told to those in lonely havens.
There was the sun
And it shone down and upwards
And lit you from your belly to your hair of rust;
That iron shined once, in the tingle of the gleams.

You threw shadows for them to catch
As they walked those hills
In staunch and standing thoughtfulness.
When backwards glanced they saw you
They somehow found themselves appeased,
And let the blue sky think the things that filled their minds
And sat upon the earth
And tilled the ground,
Their hearts the rise and fall of the sun
As it came up from the land.

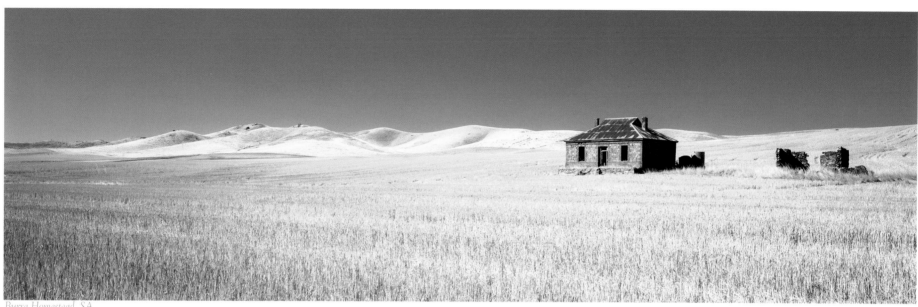

Burra Homestead, SA

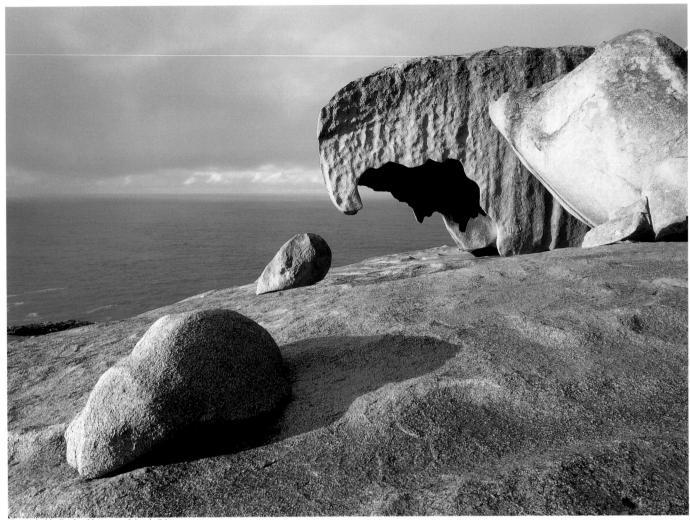

Remarkable Rocks, Kangaroo Island, SA

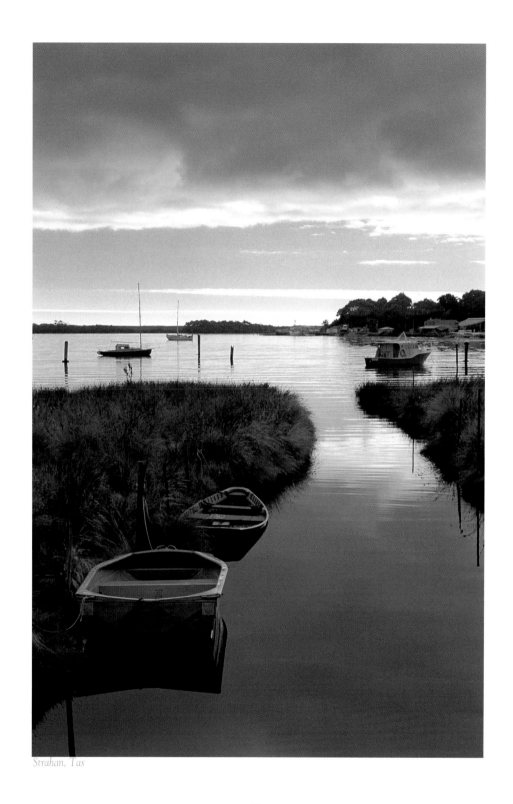

Strahan, Tas

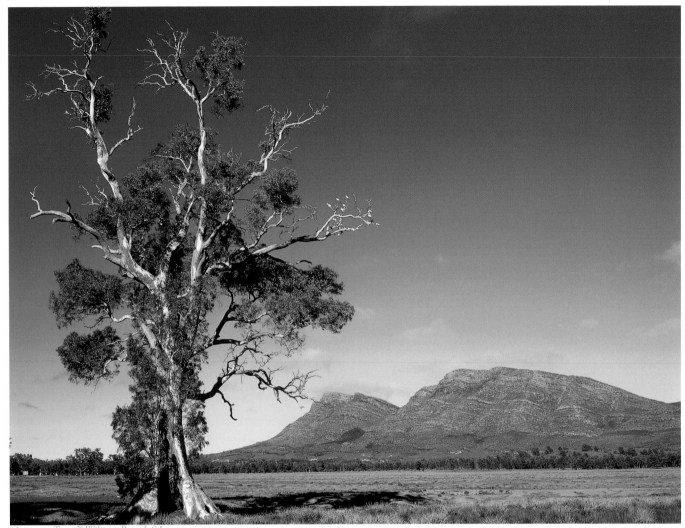

Cazneaux Tree & Wilpena Pound, SA

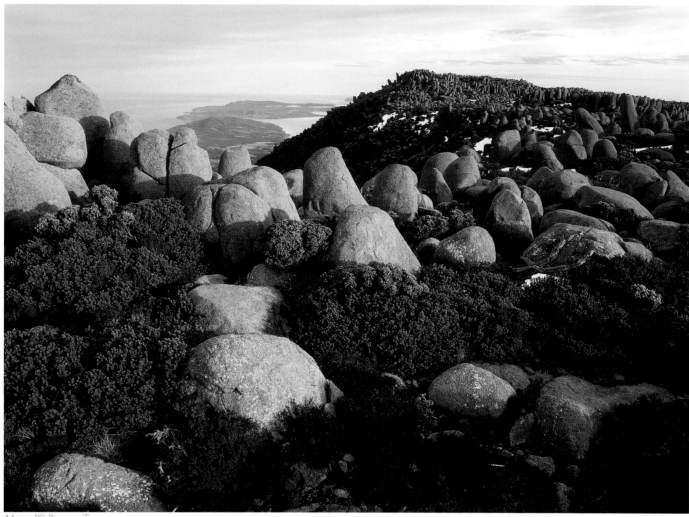

Mount Wellington, Tas

Mount Wellington

*In such a place the mysteries of the deserted landscape take cupped hands and draw
breath at the side of an altar. So snow prays to lie here and the formless dance of the
boulders keeps good vigilance by the side of the heath.*

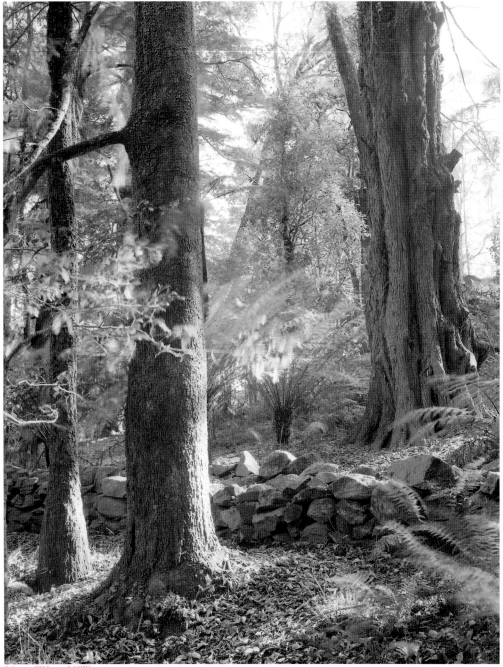

Mount Wilson, NSW

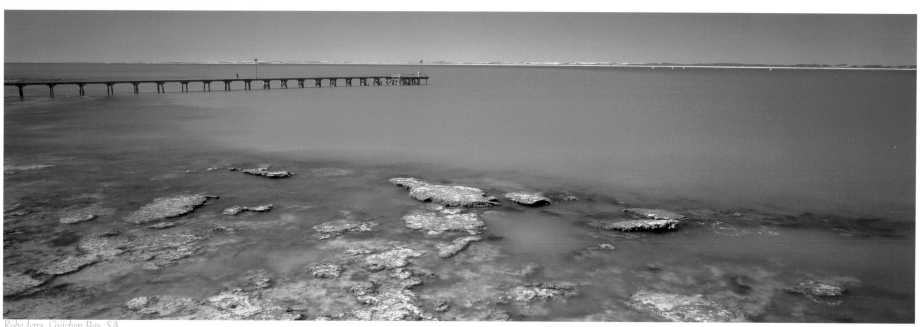

Robe Jetty, Guichen Bay, SA

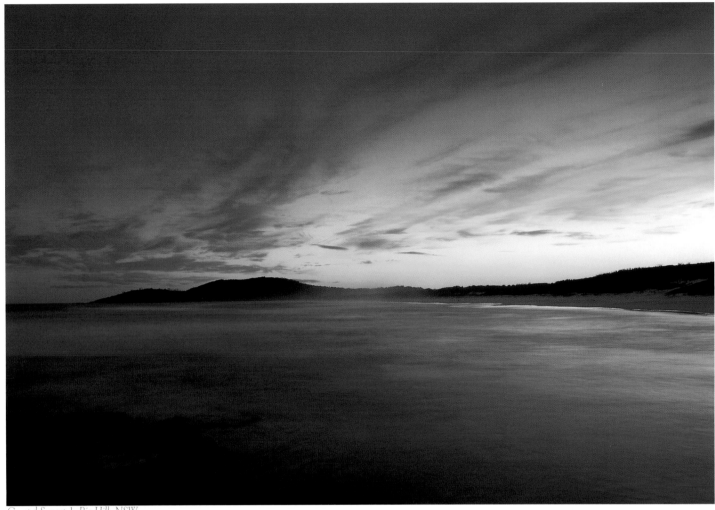

Coastal Sunset 1, Big Hill, NSW

Coastal Sunset

*Swept in like a bird, carried beneath the clouds…the bird outreaches, naked, extends
itself, becomes other extremes. The lights and shadows enfold, downwards flow the wings
into the hills.*

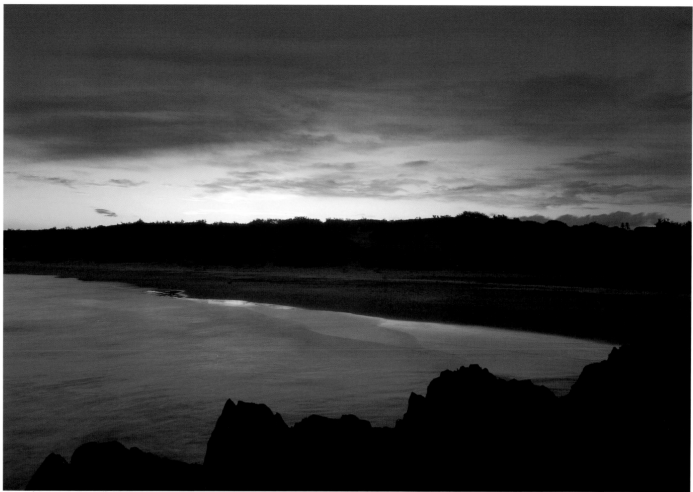

Coastal Sunset 2, Big Hill, NSW

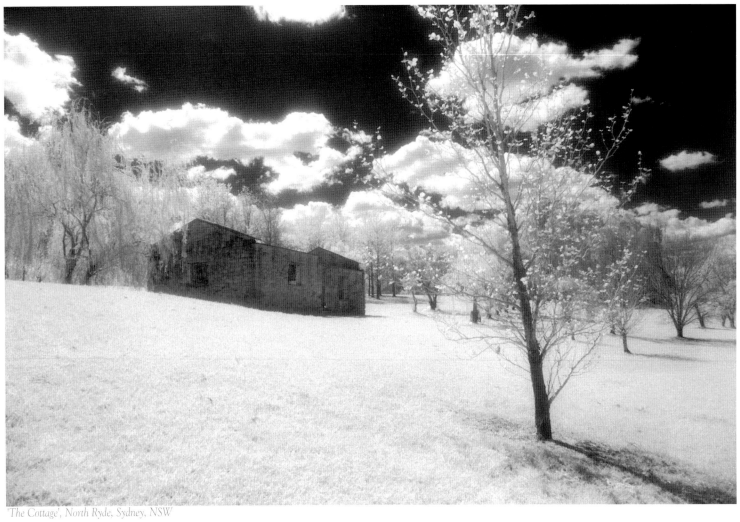

'The Cottage', North Ryde, Sydney, NSW

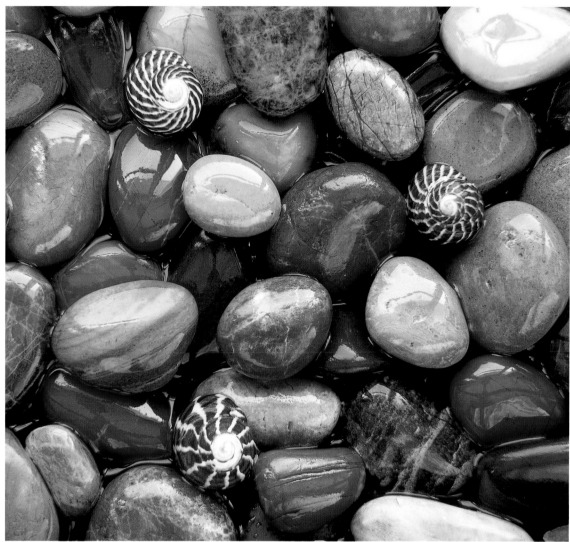

Beach Pebbles, NSW

Beach Pebbles

Singing stones that topple and swirl, coloured by the tip of the brush that dabbles in such fine palettes ever onwards, till the lid is closed on the Earth and the canvas is covered with cloths of dust.
He will wash his palette on Mars, then rove to the galaxies of a far off universe; yet when his studio catches the light, you will still find it faces the South.

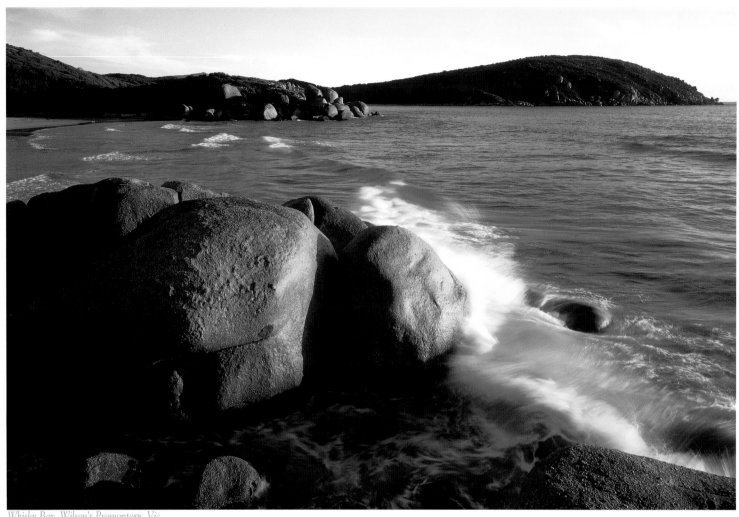

Whisky Bay, Wilson's Promontory, Vic

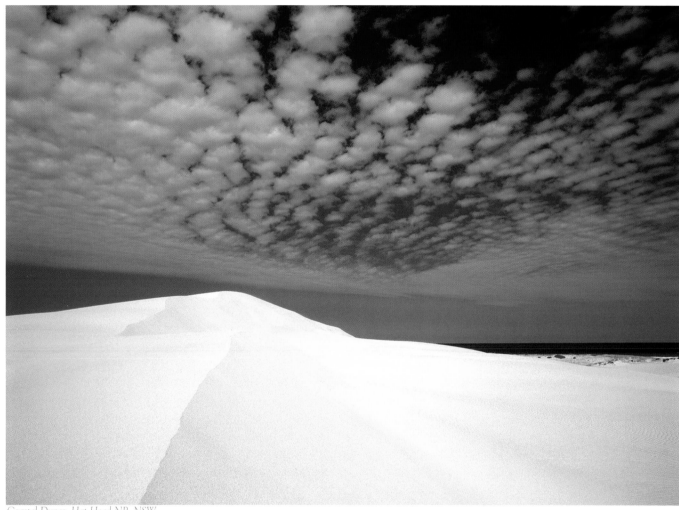

Coastal Dunes, Hat Head NP, NSW

The Earth Spirit (Hopetoun Falls)

A fullness of flesh
Wrought out
And ripped,
As chained in criss-crossed strips
Over the chest
The spirit lifts her head
And breathes defiance -
I have this earth, she says,
And all hell to guide us;
Tear not these bridal veils
From their falls to these valleys,
Let me keep presence
And blush out green,
Throw myself in rivers,
Keep the earth for my buried life,
For here is my chamber,
My church
And my sacred light,
These clefts of roots breed
At my desire
And no son of God
Will tear out my spring
And straining sustenance.
Look you to your cities,
Dig holes in their earth and bury yourselves,
For I shall take you unconscious,
Will you or not,
For these destructions!

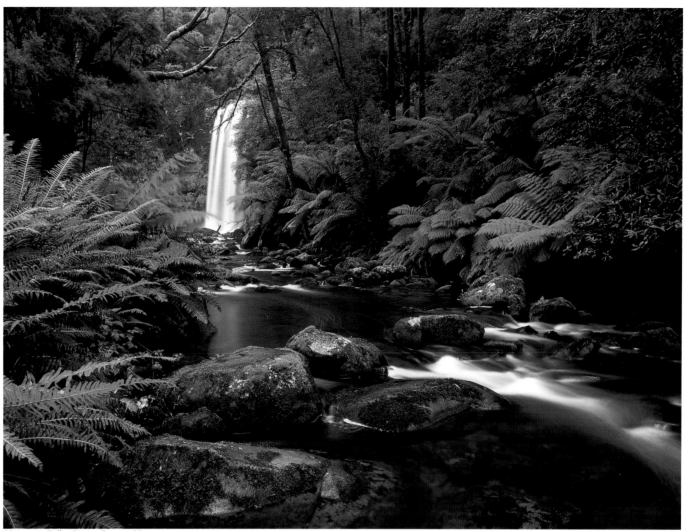

Hopetoun Falls, Otway Ranges, Vic

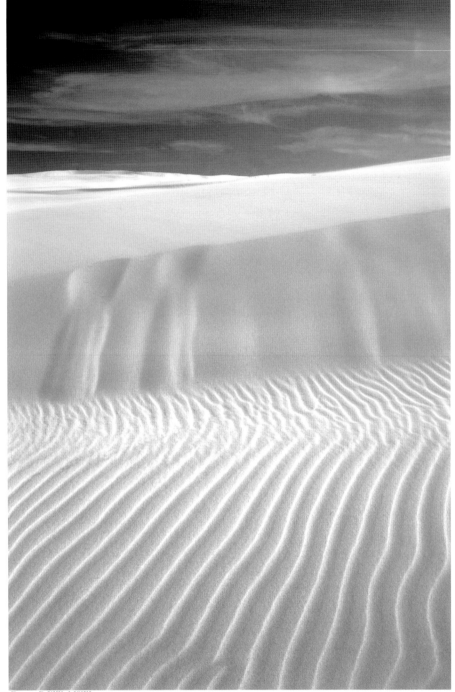

Dunes B&W, NSW

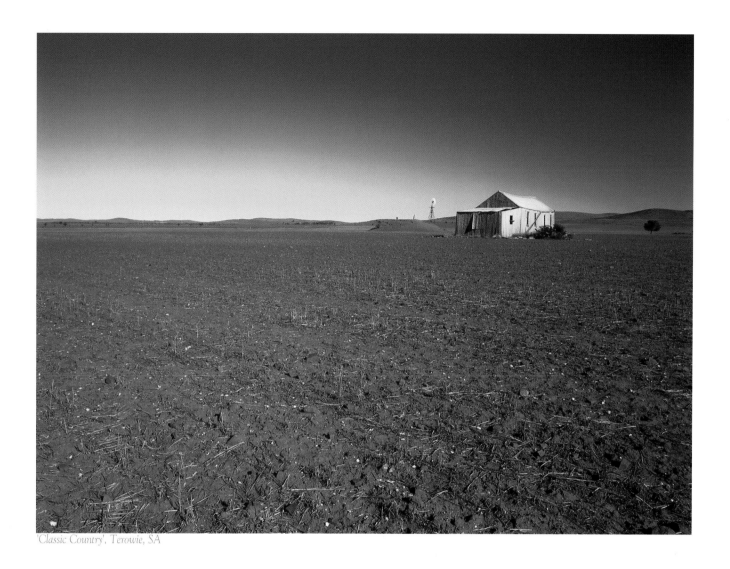

'Classic Country', Terowie, SA

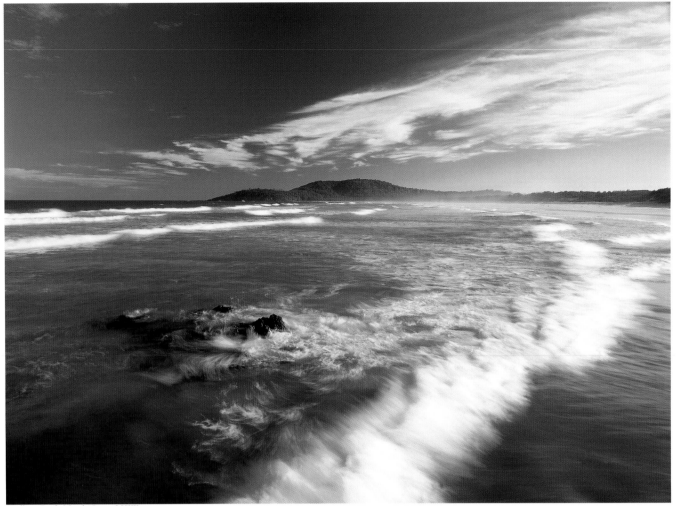

'Rolling Surf', North Coast NSW

Rolling Surf

Under the rolling clouds, twisting and spurting into the blue,
I stood on a wave's necklace
And fell to the silk
Where I lay as in a bottle of vinegar, a sprig of tarragon;
I have flavoured this ocean.

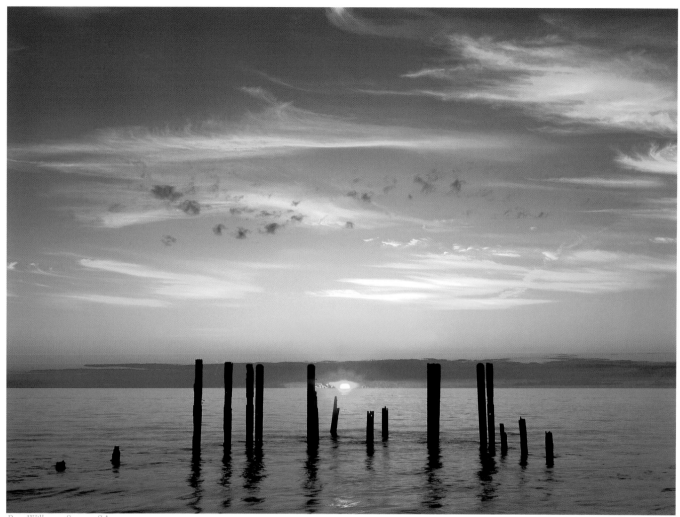

Port Willunga Sunset, SA

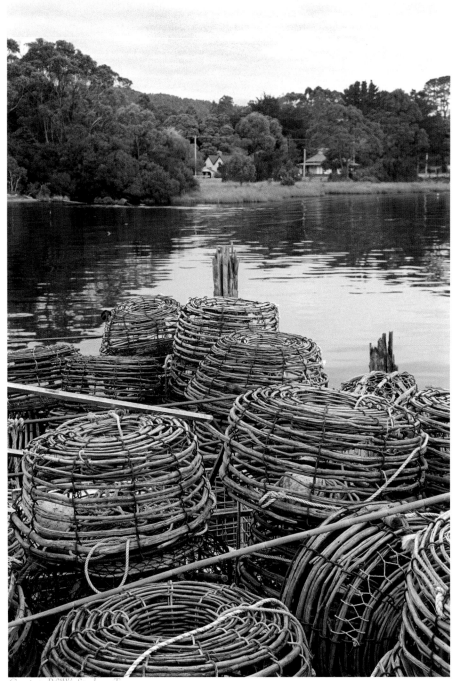

Craypots B&W, Strahan, Tas

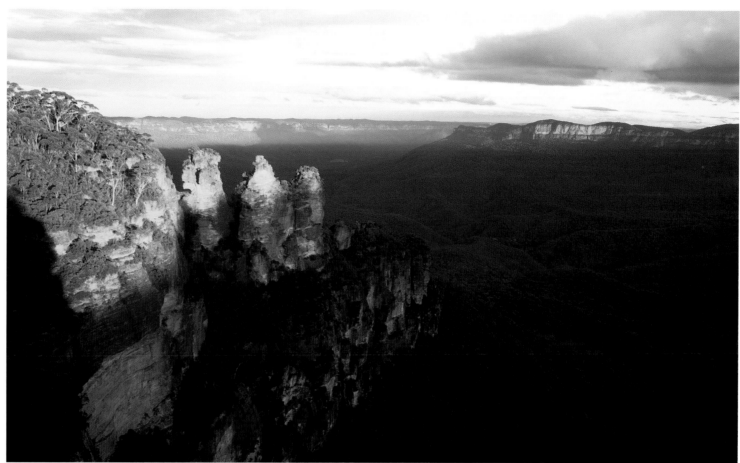

The Three Sisters, NSW

The Three Sisters

The Three Sisters look below
To find valleys of swift green trees
The rays of the sun peer into the rocks
While in the shadows are shades of hills

by Katie Sharpe (at age 10)

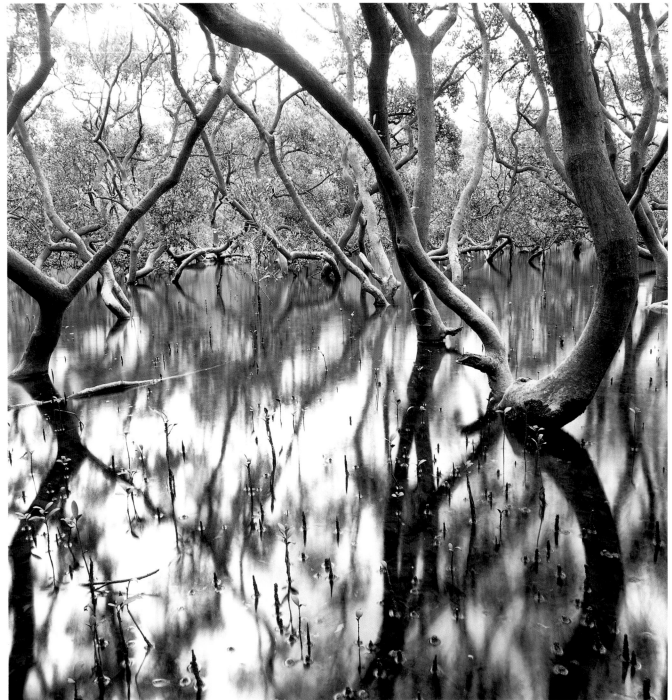

Mangroves, Pittwater, Sydney, NSW

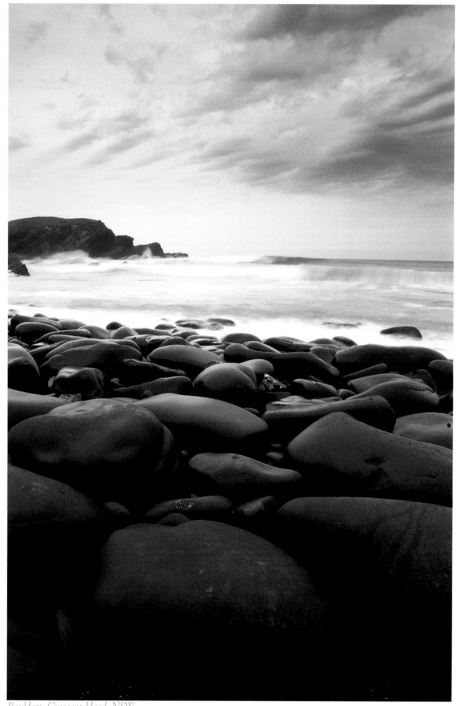

Boulders, Crescent Head, NSW

The Red Bandits (Old Gundagai Farmhouse)

Pursued by red bandits
Over the dusty ground,
Flayed alive by the sweating sun,
Taunted by moon and endless horizon,
Beating a drum.

The house gives shelter,
Beats its relief,
Sings into the aging night-hours
With constant wind-rhythms.

Am I lost in this darkness of spider scuttles?
Prancing and preying on my mind
Like ponies
The grass settles
In this hidden land.

Like a stormed ship
I keep in the hold of my ruin
Until it becomes as outer bodies
Become our souls,
My earthly self
And scent of paradise.

The red bandits of the desert give up their chase
As the dawn comes,
Bringing with it strange winds.
When they come to this house
They will find my bones
Trapped in this ancient sarcophagus.

But, knowing I am safe,
I wander out of my doorframe
Through a lit sea
Under a moon.

The pink sky will witness my defeat.
I give up my body
To the sun.

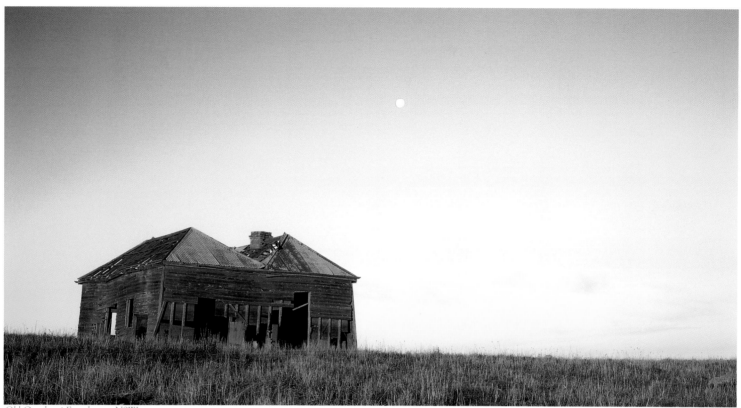

Old Gundagai Farmhouse, NSW

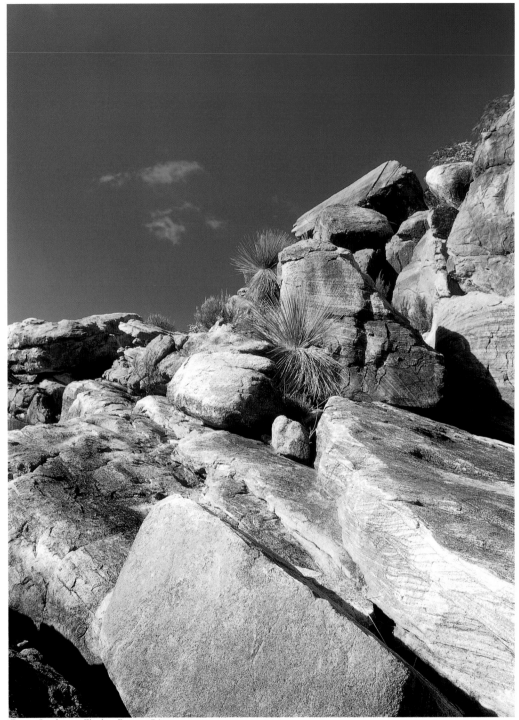

Desert Sandstone, Flinders Ranges, SA

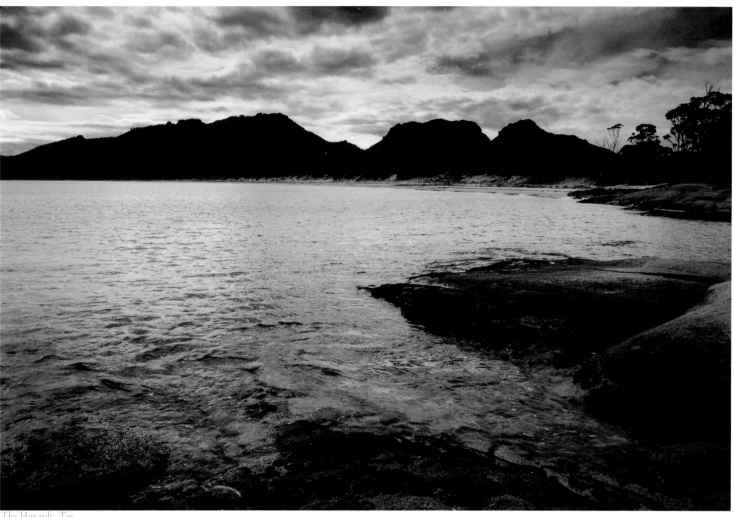

The Hazards, Tas

The Black Mud (Road to Appealinna)

We were in a shop like a dead end, and a road
bled off into the horizon…
"It's ok unless it rains" the shopkeeper said and we
looked up at the white-grey clouds.
Rain? Rain? Light sprinkles, nothing wet could
come -
Forty minutes and we'd be off the beaten track
and back on tar.
Mum, Dad and kids in a yellow old sedan, the
light red dust like a bunyip followed;
The grey clouds gathered and sent the Spitting
Gods,
The windscreen wipers scraping near-dry glass
ev'ry five minutes.
And then the slip…
And then
The
Slide
Winding
To
And
Fro
While Dad yelled
"Christ!"
And grabbed the frickin' wheel
To no avail.

When mum got out
Her shoes became ice-boots,
I'd nearly say 'stilts' -
Platforms she walked on
Of thick red mud.
"Stay in the car" she said,
And us kids were distributed
A feast
Of chips and lollies.
Dad and mum went searching for a stick

Among the bushes.
She found a lamb's leg
But decided
She'd come back for that
If we were desperate.
Were there trees left in the world?
Nothing to pitch the tyres
From the ditch,
And not a car from end to end -
"Road Closed"
The sign would've said.

The prospect of a walk on well-sucked shoes
Didn't thrill our parents
'Specially as that walk 'd go
For twenty k's at least.
The sunset wasn't miles off
And the chips our only sustenance -
And that becoming fast of no more substance
Than a mirage.

When off in the distance
We thought we saw one
(a mirage that is)
A car coming the way we'd come
With a driver like a King -
A little twist and turn he did,
No more than a ribbon in the wind!
Yelling and screaming we all jumped out
And hailed that car down like lunatic hitchhikers.
A car of ordinary size, five seats,
With five big Aboriginal blokes,
Three women and a truckload o' kids.

"Yeah, we're used to it," they said,
"We'll get you out,
No worries,

We'll drive behind -
It's the Black Mud."
The kids spilled out like lemonade upon the road,
The women screaming, "Get back inside!"
And my mum with her hands up to her face
Saying, "Oh I'm sorry," and "Oh I do apologise."

Eventually the kids were all back in,
The hefty guys had grouped beside our wheels
And shoved us out into the middle of the road
Where we drove along at 5 k's on icecream.

Five times we stopped
And every time
Their car would empty out -
The kids were caked in mud from head to foot
And getting edgy for a peg at us!

When oh, thank God! the bitumen came in sight
And after piling thanks on them in floods
Dad drove the smoothened road
Like melted chocolate down a tongue.

A sign for a service station
Said 'Mobil cards accepted'
And when we'd filled 'er up
Dad fingered in his wallet.
"We don't accept those,"
Said the bloke in his crusted pair of shorts.
"Sign back there says you do."
"Sign? Must be a pretty old sign,
No one ever comes from there."

The rain didn't let up for a while,
Few days, maybe a week,
And I often tried to imagine
Just how strong a lamb's bone is.

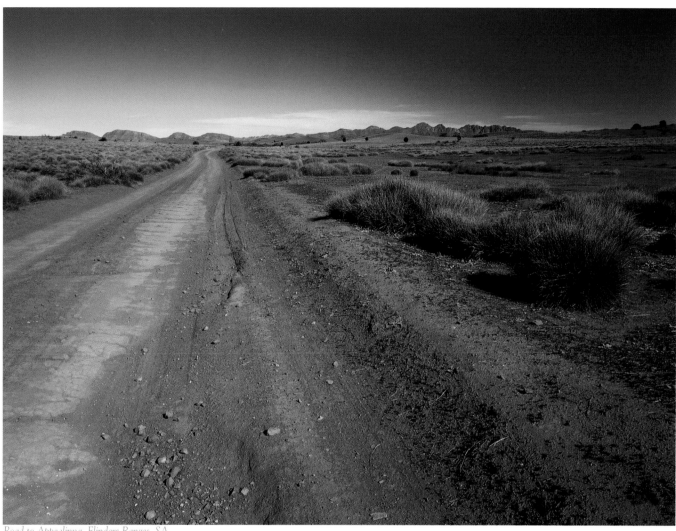

Road to Appealinna, Flinders Ranges, SA

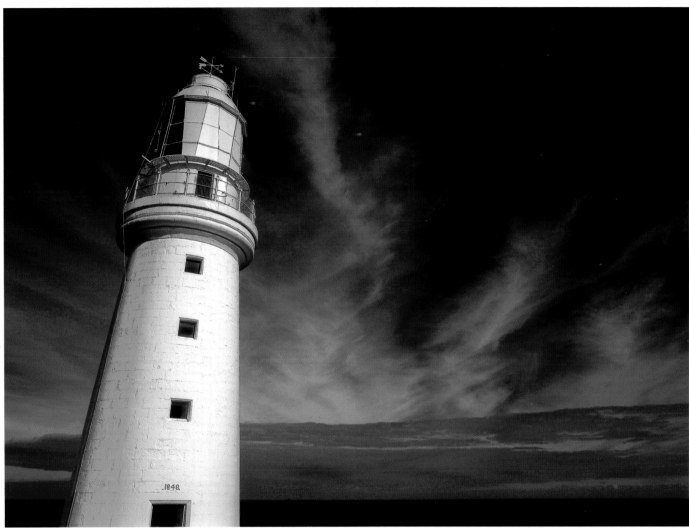

Cape Otway Lighthouse, Vic

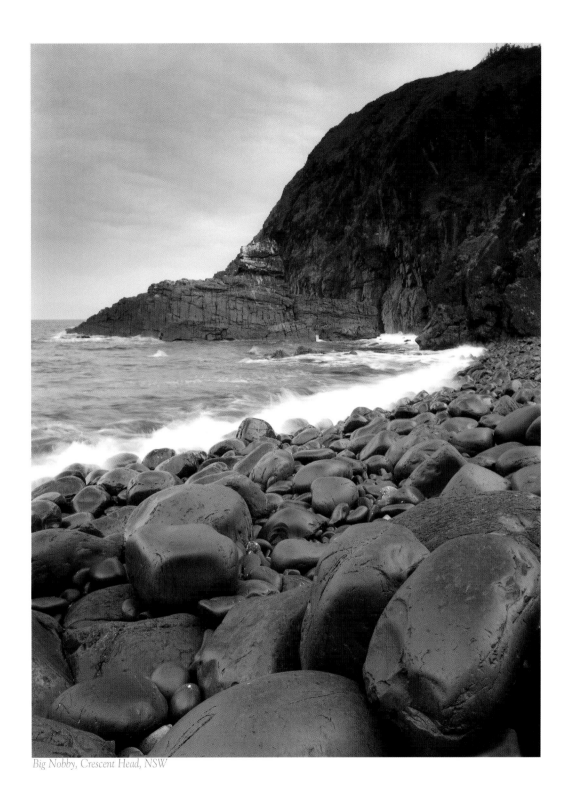

Big Nobby, Crescent Head, NSW

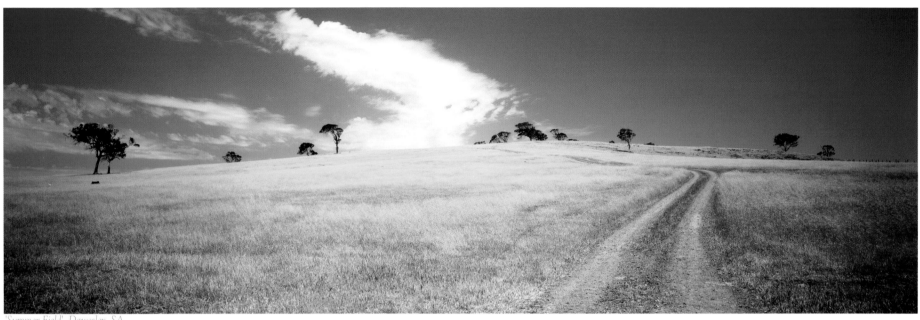

'Summer Field', Dawesley, SA

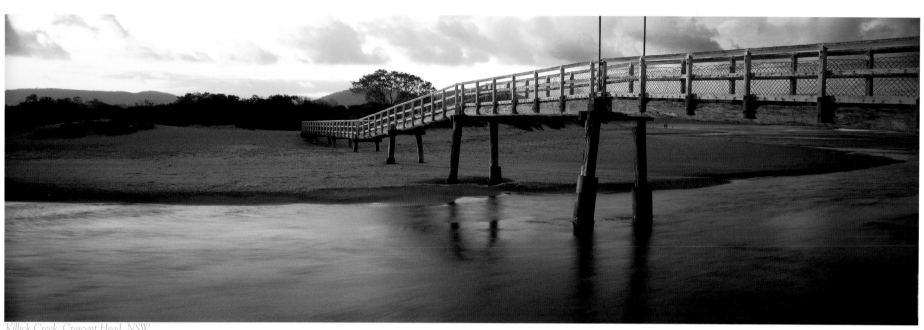

Killick Creek, Crescent Head, NSW

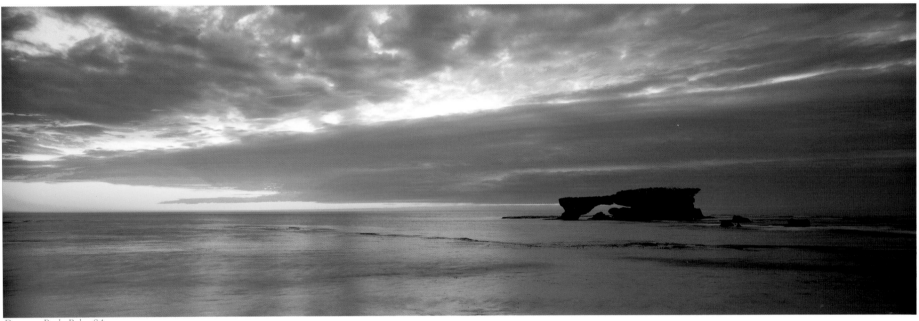

Doorway Rock, Robe, SA

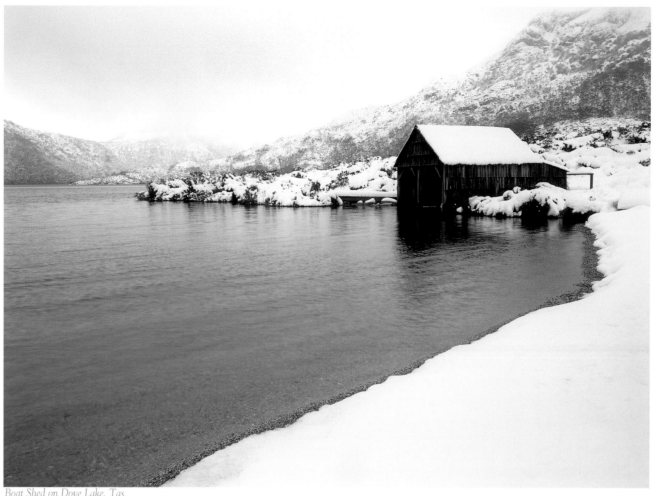

Boat Shed on Dove Lake, Tas

Boat Shed on Dove Lake

*Like four seals their gumboots splash the water, tumbling drops into each other's
snowladen hair - two men bashing the snow and kicking up high ladles of dove-feathers,
laughing and leaping ripple over ripple like rabbits, to the edge of the mountains.*

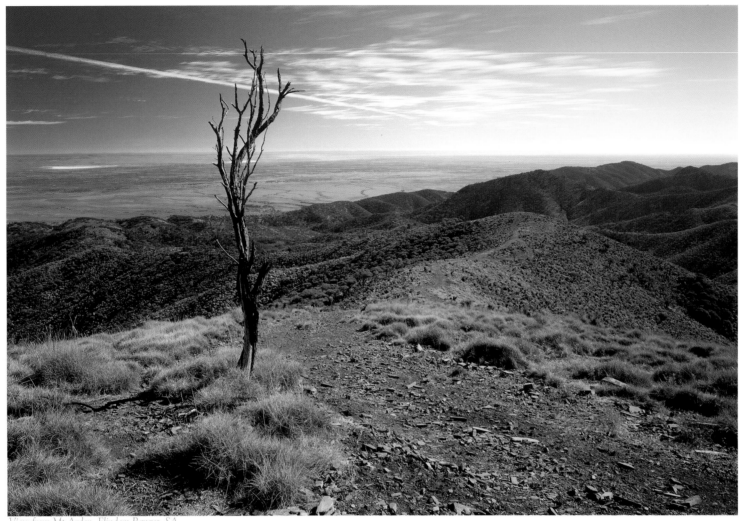

View from Mt Arden, Flinders Ranges, SA

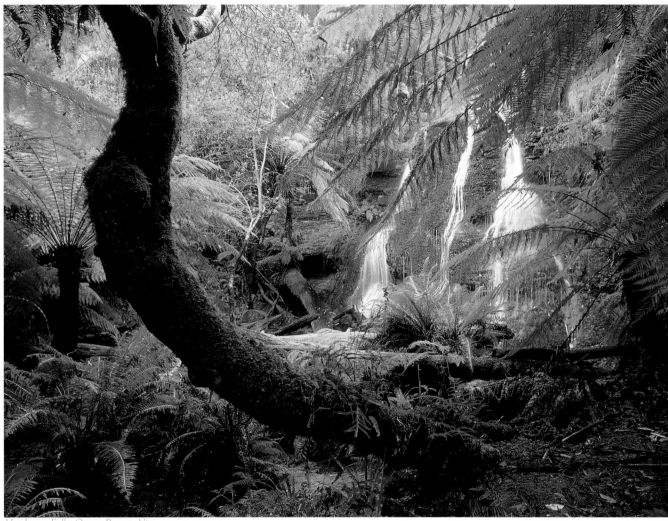

Henderson Falls, Otway Ranges, Vic

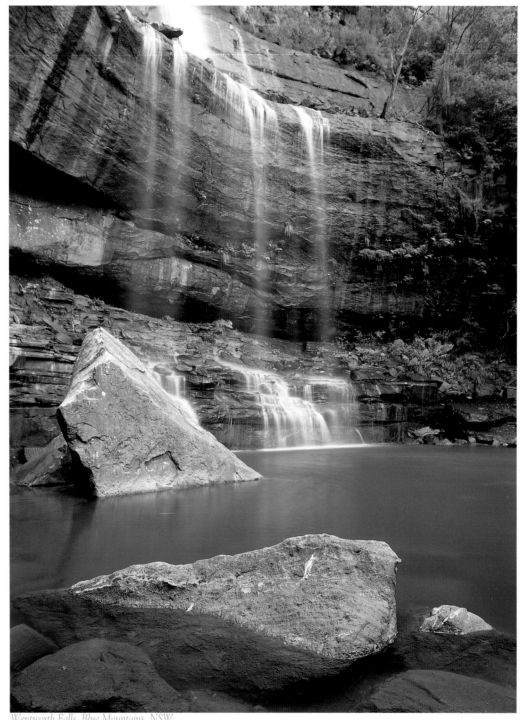

Wentworth Falls, Blue Mountains, NSW

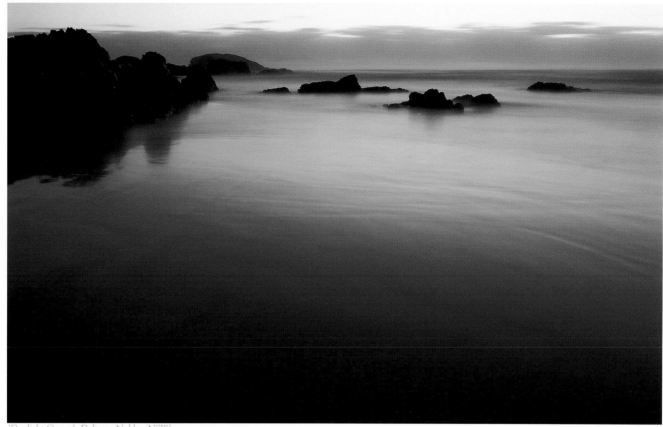

'Daylight Comes', Delicate Nobby, NSW

Daylight Comes

The forest trees cling close beside the way
And frost-filled air o'er shrouds my face and hands
As coming down the hill at break of day
I look across to where the heron lands.
And could I see your face in fading stars
Or hear death's voice pass pale through heaven's winds
It would not move me much, for nothing mars
The heart of one who life's contract rescinds.
For you, in death, have freed the chains of life
And sent them gyring to a greyish sea
That swells and struggles in a baleful strife
And weeps as yet I cannot weep for thee.
So as the heron folds its wings to sleep
Thus do I fold my love, though it be deep.

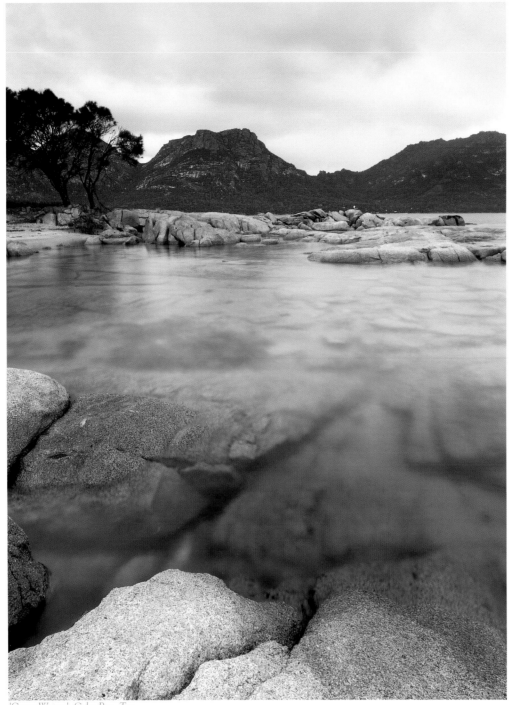

'Green Waters', Coles Bay, Tas

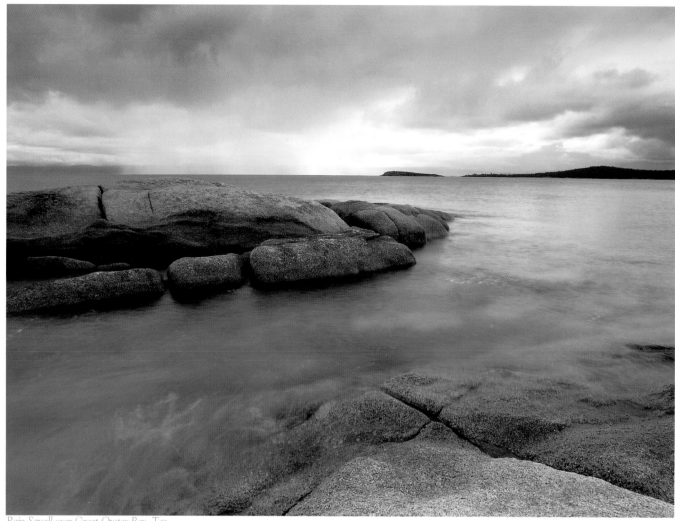

Rain Squall over Great Oyster Bay, Tas

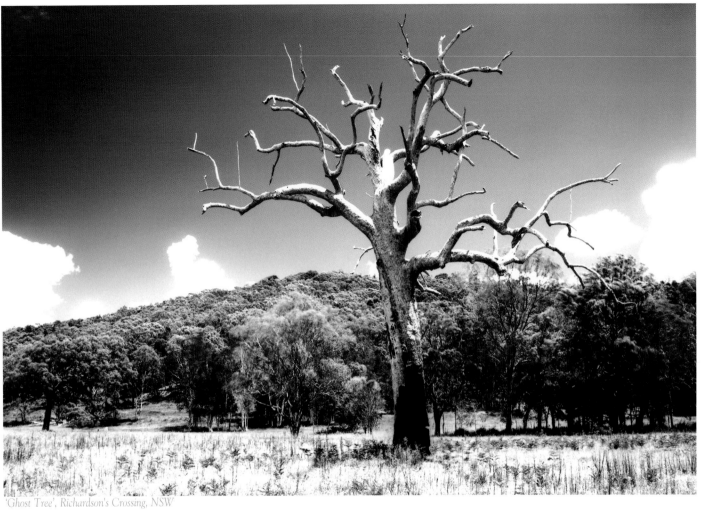

'Ghost Tree', Richardson's Crossing, NSW

Ghost Tree

Once upon a time twelve birds sat upon a silver staff
In the middle of a forest.
A hazy place, a distant place, where the sense of long lost things gathers
And then withers.

So the staff had turned all things
To death
And kept its flock of birds
Enchained
That now they have but bones for wings
And sliding snow for breath.

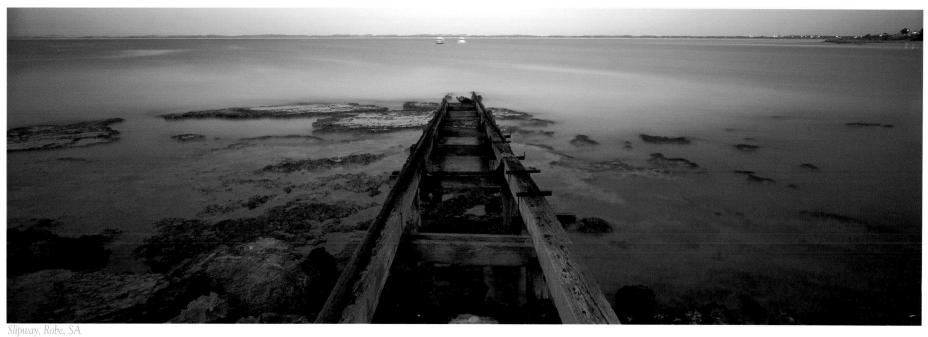

Slipway, Robe, SA

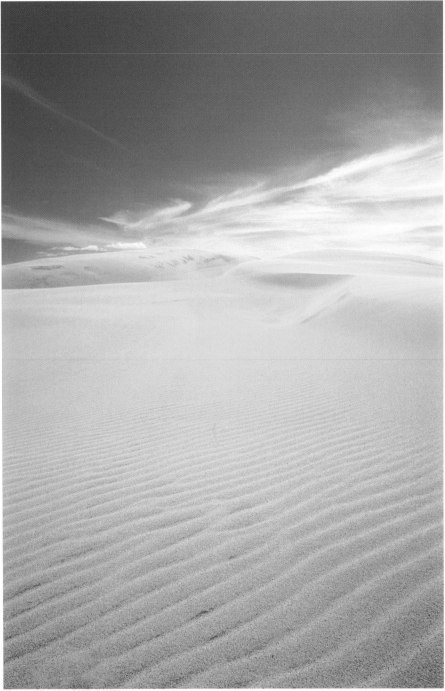

Dunes, Hat Head NP, NSW

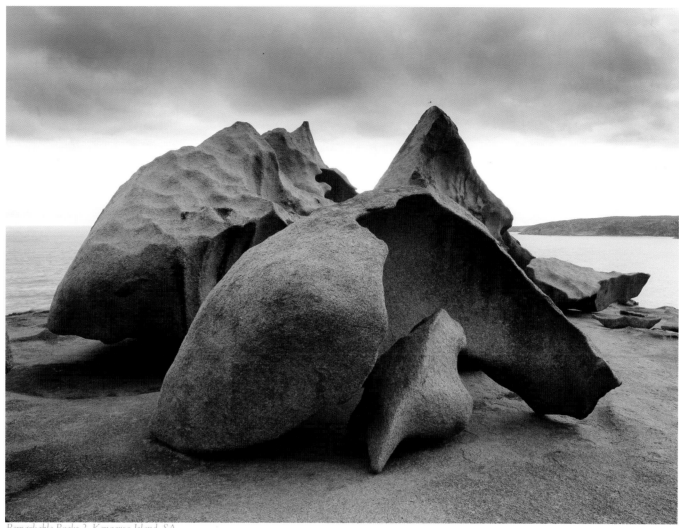

Remarkable Rocks 2, Kangaroo Island, SA

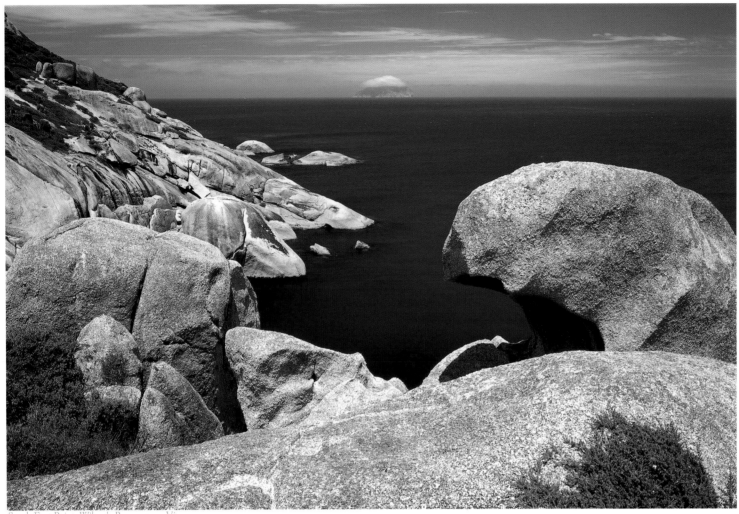

South East Point, Wilson's Promontory, Vic

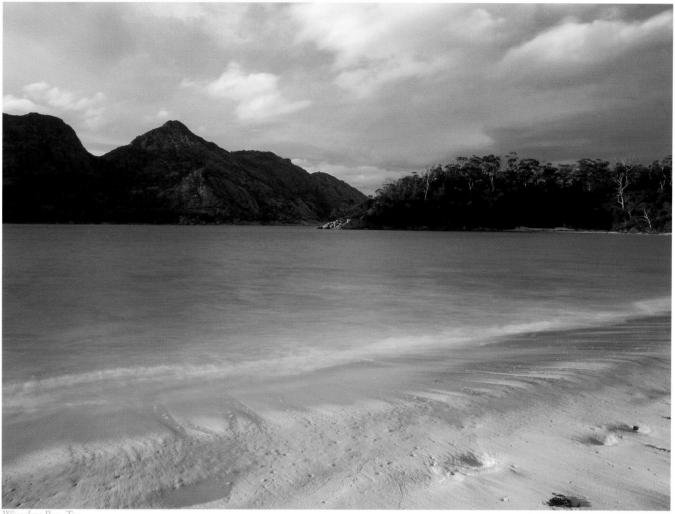

Wineglass Bay, Tas

Wineglass bay

When combing back the waves you will find seashells.
A frog's ribbits and the scent of salt
That ties itself to your lips like rope,
Rustles before your tongue's small movement.
The water turns from pearl to pink
As the wind drives the waves into the sand
Making them unfold like rose-petals.

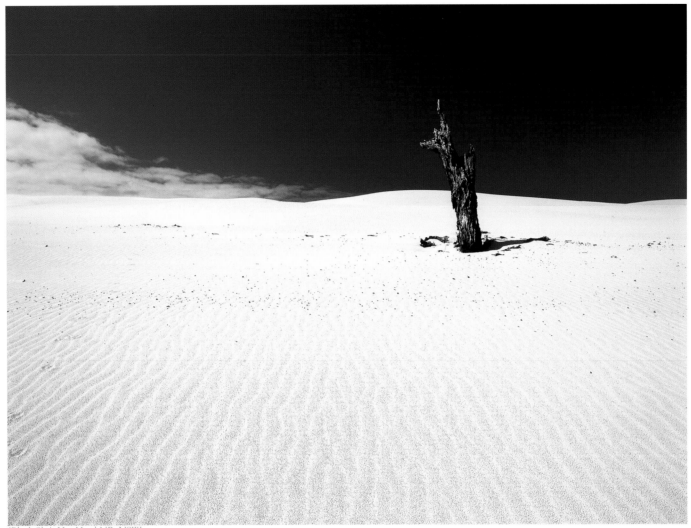

'Black Sky', Hat Head NP, NSW

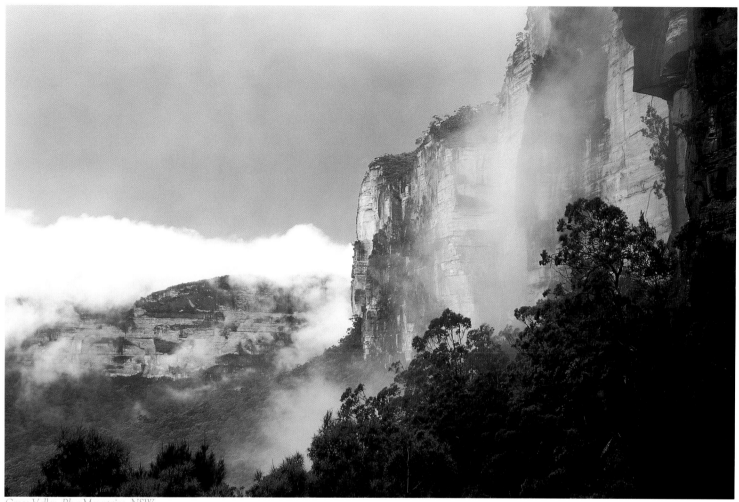

Grose Valley, Blue Mountains, NSW

Shell on Pebbles

Under sea nor sky,
Under light nor dark,
Breasted and spaceless
They found the spark
Lit like a moth in a flame
As a bird spread her wings

This eye sees all things
Lined like juice upon a glass
Swallowed whole down a throat
Without walls or linings

Into the ethers and up
Burnished and buried
Something moved in my eyes
And the stones danced
Upon an oceanshelf.
I will let her see my life
And, once seen, let her dance
Herself
To the skies.

Under sea nor sky,
Under light nor dark
There they lit the spark
And the moth danced in the flame
The dance unending that turned
And turned again

Swaying.

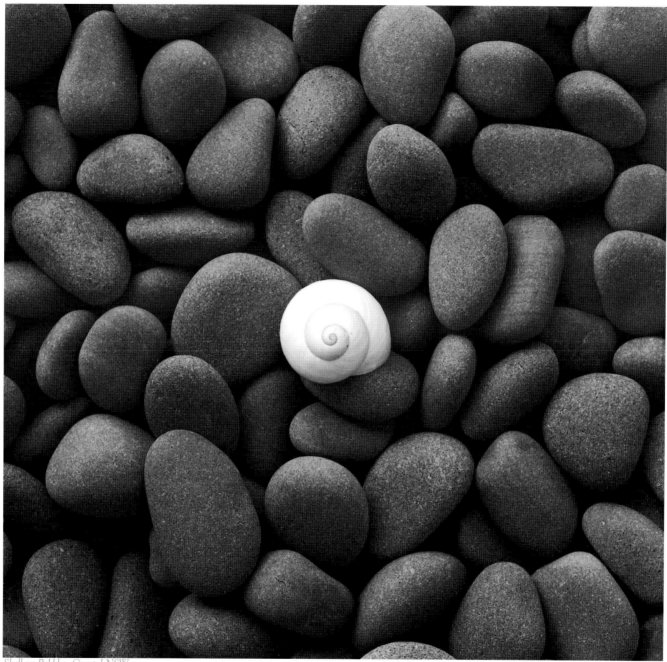

Shell on Pebbles, Coastal NSW

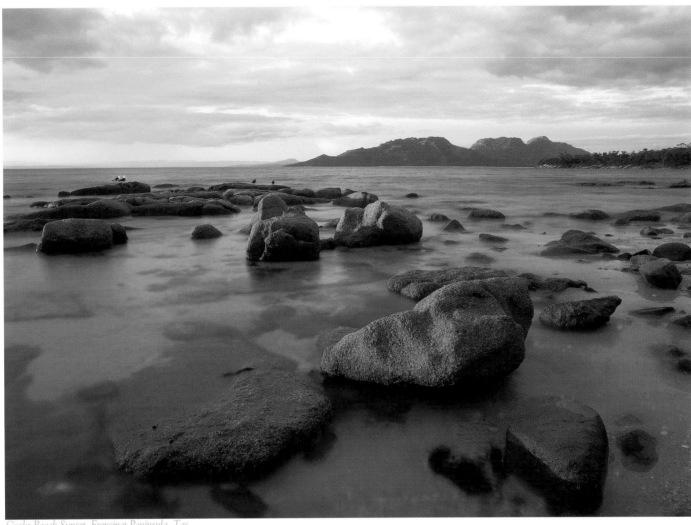

Cooks Beach Sunset, Freycinet Peninsula, Tas

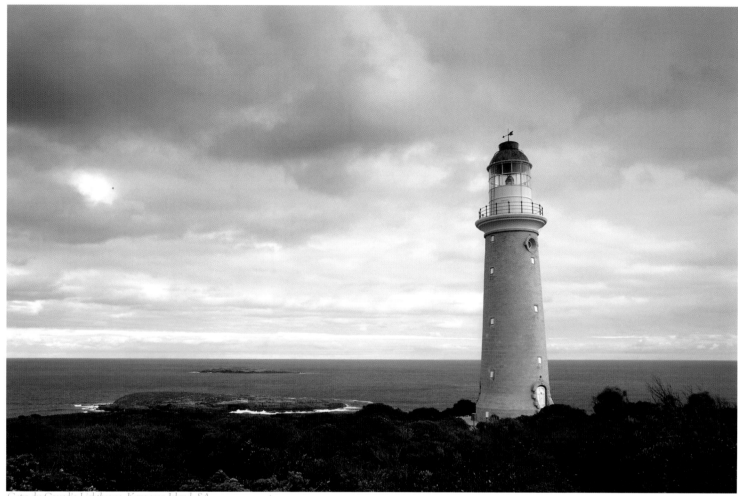

Cape du Couedic Lighthouse, Kangaroo Island, SA

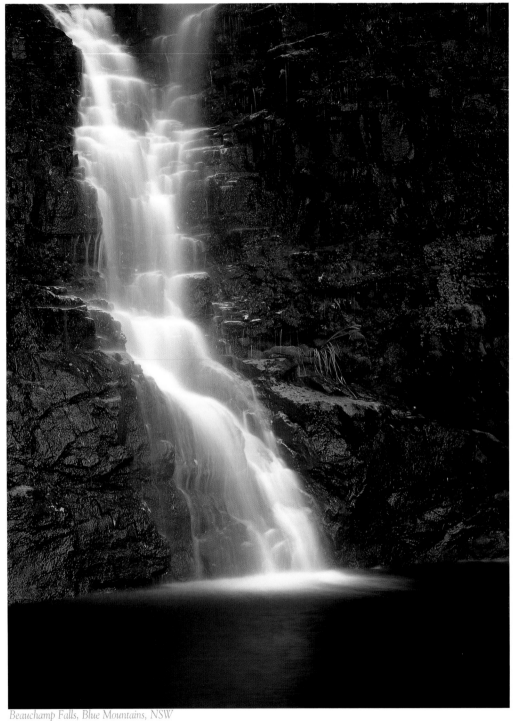

Beauchamp Falls, Blue Mountains, NSW

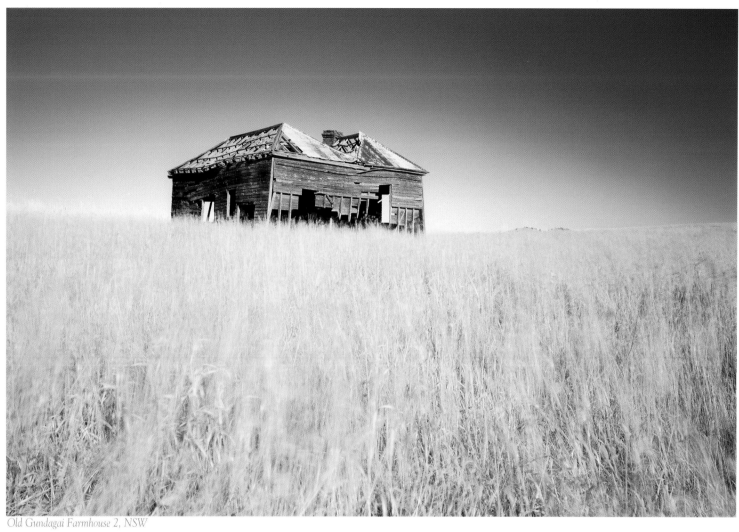

Old Gundagai Farmhouse 2, NSW

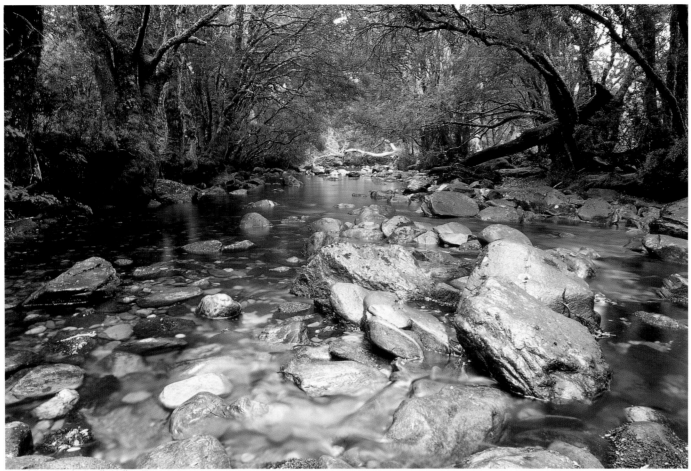

Pencil Pine Creek, Cradle Valley, Tas

Pencil Pine Creek

Under bowers
Two water spirits
Trip hand in hand
After marriage.
She spreads her veils over rocks
He lays for her to tread
But when she cuts her little white foot
Small droplets of blood inseep.
And when I came scrabbling as a small child
With my net,
Scraping the moss and staggering,
I heard the whispers
Of those two lovers
Singing above the waters
And I saw the glimmering of her long veils
And their shadows passed over the trees.
Long I stayed till my feet were ice
Between the blood-dyed rocks,
And listened to the lovers
Whose blithe and secret trust
Has stayed within the throb of old hearts
With youth's blood.

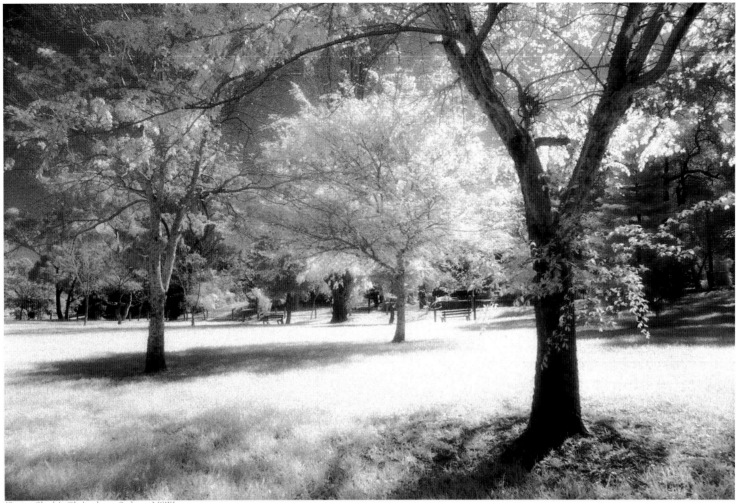

'Spring Shade', Cheltenham, Sydney, NSW

Spring Shade

Prisms of light and colours that stretch beyond the eyes and into imagination's realms.
When I stepped out onto the grass I was enfolded in a new world where light has
forgotten itself and danced naked, unseemly, except to those who know, and are afraid of
shadows

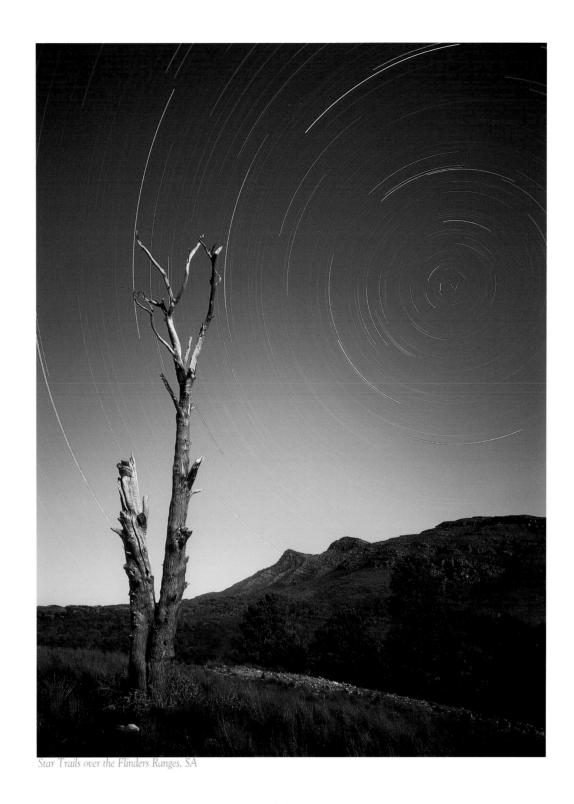

Star Trails over the Flinders Ranges, SA

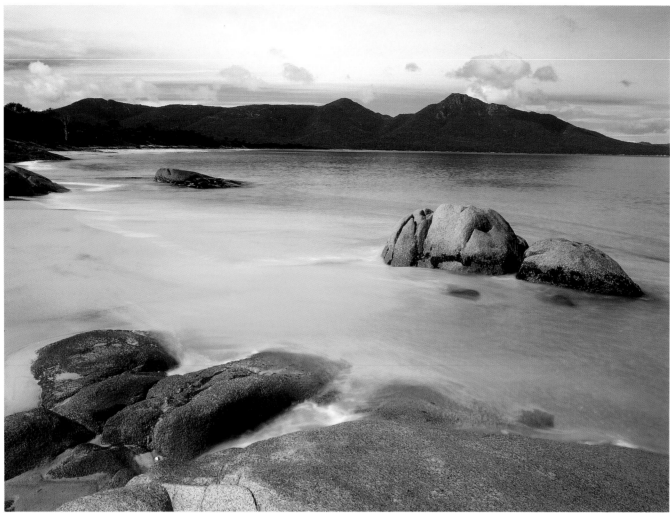

Hazards Beach 1, Freycinet Peninsula, Tas

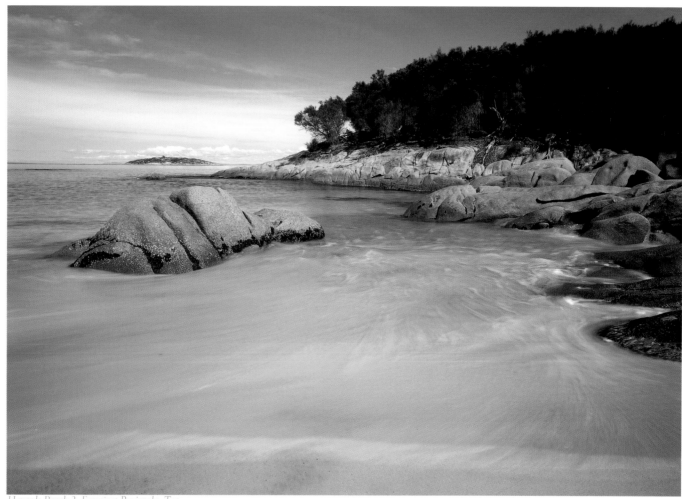

Hazards Beach 2, Freycinet Peninsula, Tas

Bicheno Blowhole

Above the clouds
There is an ever-lived retreat.
The storm sails down
And brings with it foul force of things to come.
Beyond the sea are mountains,
Beyond the mountains
Cool light and a powerful dominance.
Scraping over rocks come the hands
Of scathing spirits,
Spiked and meaningless
Unlike the waters
That spurt from out the blowhole.
They say 'We shall be free!
We who have chains are free!'
Thus nature sets into recourse
This clamoring for dominance
And gives to the waves and the waters,
The clouds and the dry rocks
A spiraling emergence -
They come out of dry palace
And windswept frost.
Above the clouds
There is a retreat,
But such places of light
Pour down their wisdoms
Into the sea.
The sea springs up,
Cool forests rain down in salt spray
And say to the skin that meets them -
'We shall be free!'

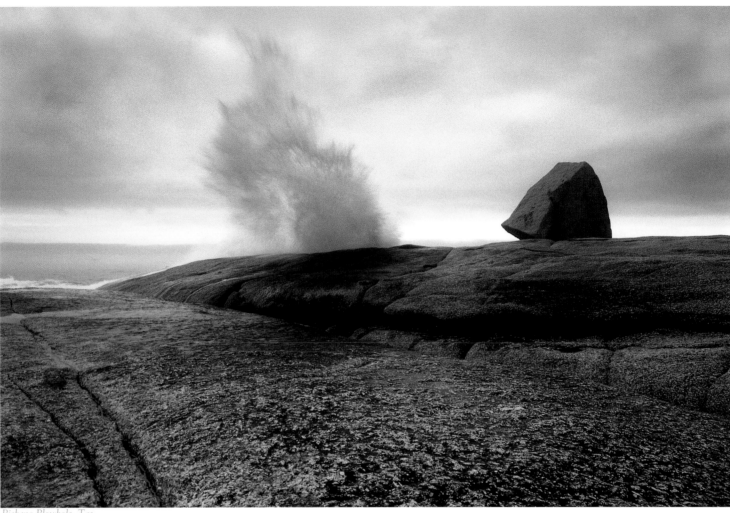

Bicheno Blowhole, Tas

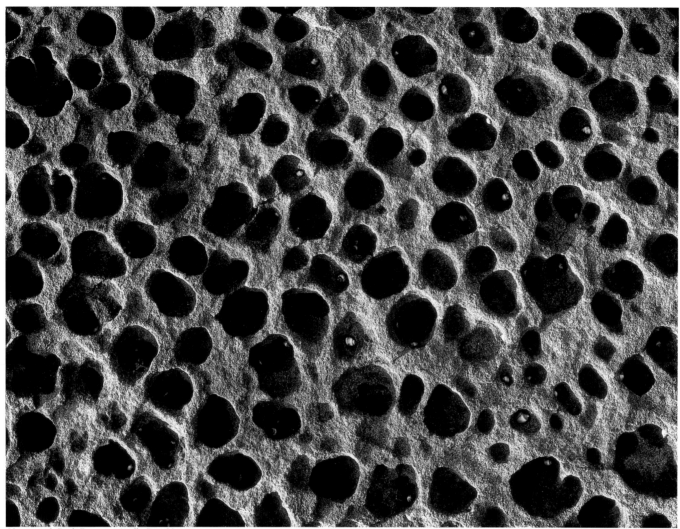

Honeycomb Rock Patterns, Apollo Bay, Vic

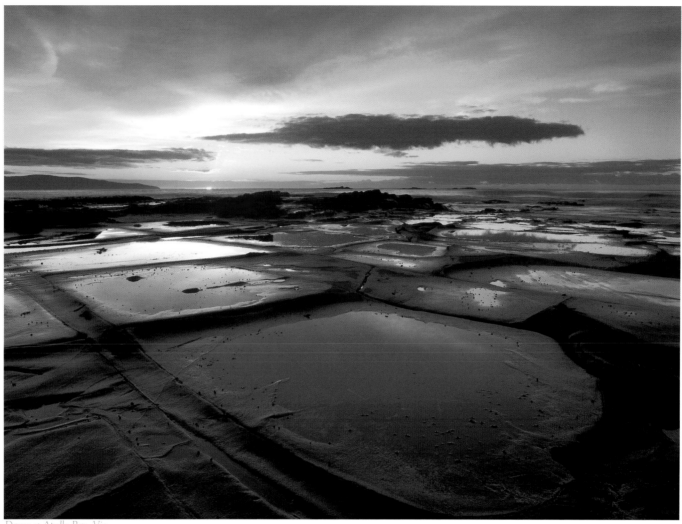

Dawn at Apollo Bay, Vic.

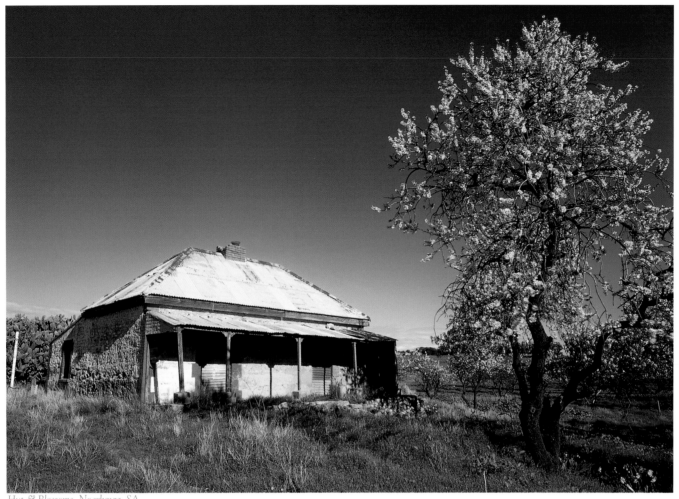

Hut & Blossoms, Noarlunga, SA

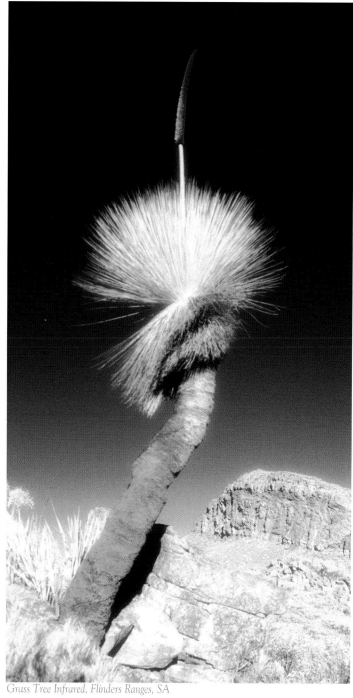

Grass Tree Infrared, Flinders Ranges, SA

Shipwreck at Loch Ard Gorge

Black cliffs give off a pale of slime to the watchers.
When the sea is calm we can see this shaft frozen
But in a storm
We are riven and shaken to dust by the racings
And cannot see nor watch
But we must leap into the plummets of wave
And give up our lives for lost.
Death comes only to those with grace,
The sea gives as nature's deserts inscribe,
This way and that we come through a passage of cliff.
In the fog they came upon the coast too quick
And only two were saved.

She was no swimmer
But fell in large skirts to an ocean so vast it seemed the swell was
bottomless
And would suck her in to a fury where never a breath would come,
Nor a shaking of the soul from the body,
But she would be a gust of wind in the mind forever and forever
Singeing and turning the lost waves beyond the end of the earth.

In skirts logged with sand he found her
Where he came,
Breasting one wave and another,
Casting up arms against the cliff and then finding the tides
Answered his fears and pushed backwards.
He wove a path, this sailor,
In a body for a boat
And found the sand his refuge.

Salt water defiled his vision -
He thought he saw a boot and laid his palm upon its sole,
Threading fingernail through the cracks.
The body of a girl lay skirted round with high cliffs
Enclosing this lonely gorge.

He rose and sucked back her breath, loosing her collar,
And with a case of brandy washed on the beach
Revived the pallored life.
The sun divided their eyes.
The common sailor swore to reek vengeance on Christ
As he climbed and dropped blood on the sand,
For those cliffs engorgéd hell
And he was meek, yet for saving his life, no matter what the cost he gave.

Who can say what she thought as she stayed on the sand,
Opening and shutting the locket
And drying the sea-stains, in the sunlight,
On her mother's face.
The sea will wash life from life,
The drowned would be dashed on those cliffs
Yet never in-floated, never washed on a beach.

The shifted waves lashed at her knees as she sat and stared out
Through the crack, piecing the two cliffs together
And then wrenching;

Uncommon tired her mind felt
As it grew dark and she slept.
The sailor returned to the cliff,
He had followed horse prints and found men…
How strange is life to pursue beasts
And find fellows
Who will rescue us and give us clean sheets and warm meals.
When the rescue party called out from the cliff
'She was saved!'
Saved at the last from death
Which had caked her to a breach of living -
She would never more live
She felt,
As she rose and gave them her hands
With the locket cupped closed.

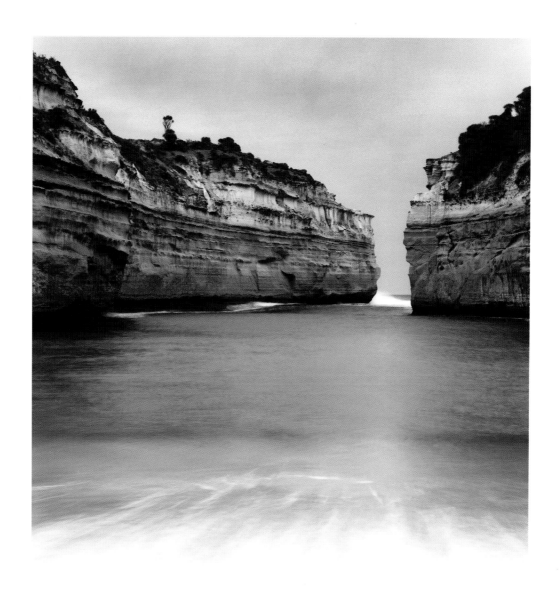

Loch Ard Gorge, Port Campbell NP, Vic

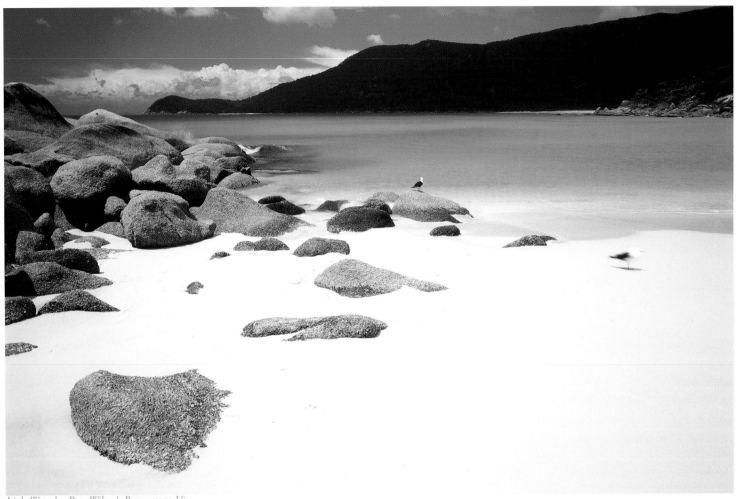

Little Waterloo Bay, Wilson's Promontory, Vic

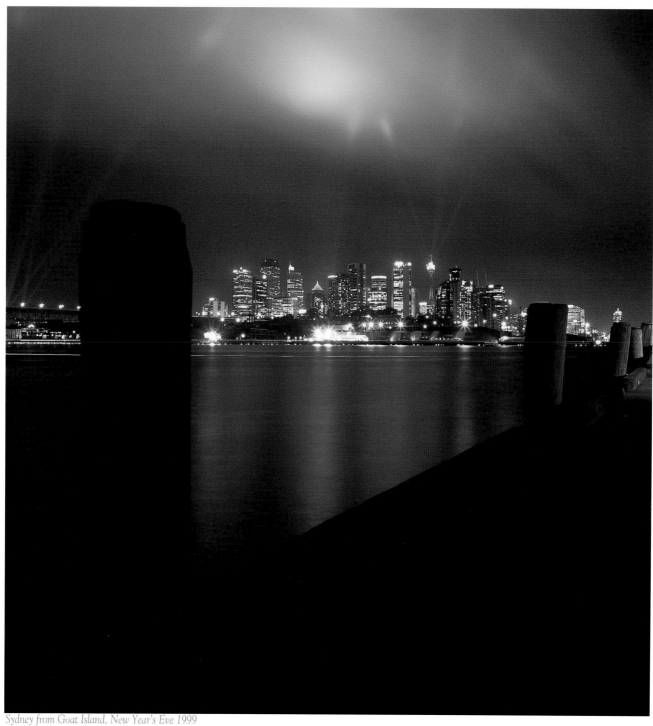

Sydney from Goat Island, New Year's Eve 1999

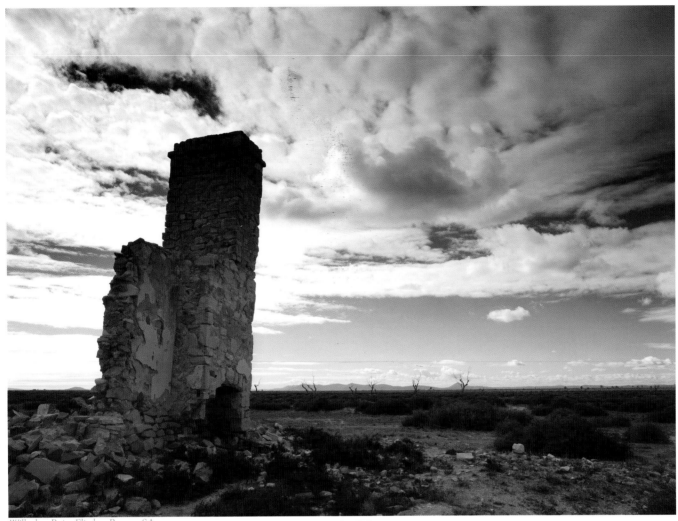

Willochra Ruin, Flinders Ranges, SA

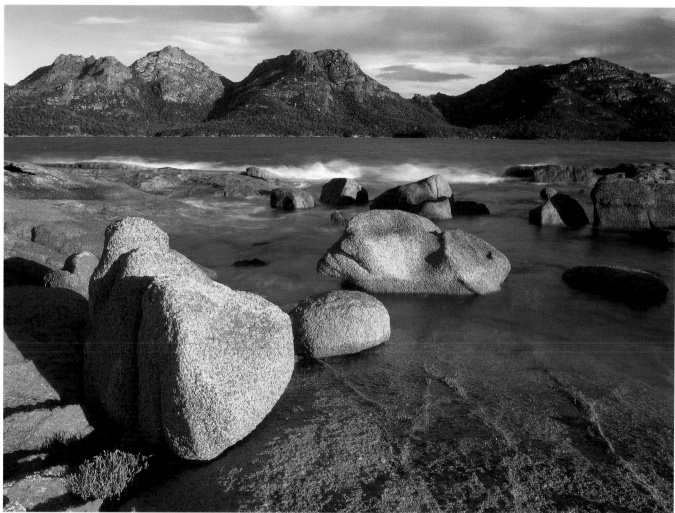

The Hazards from Coles Bay, Tas

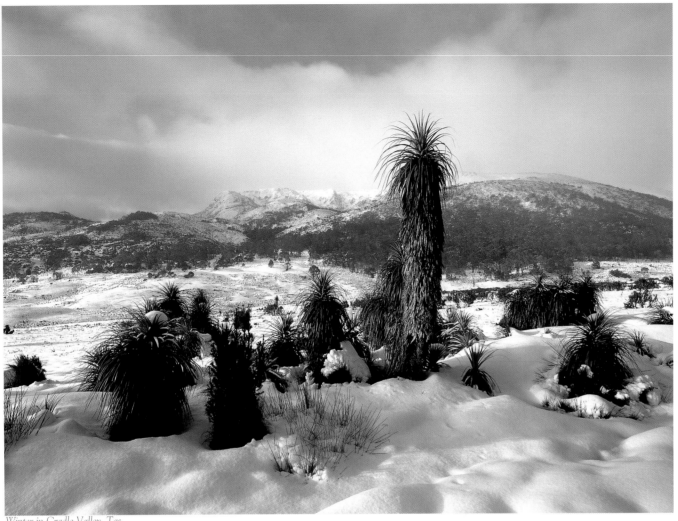

Winter in Cradle Valley, Tas

Spanish Pandanis (Winter in Cradle Valley)

Hey hey! Pandanis,
You have wild white skirts
And your feet dance like elephants in the winter grass.
Hey hey! Pandanis,
Shake your heads and twist your hips, for España's on your breath
And you could unfreeze the mountains!

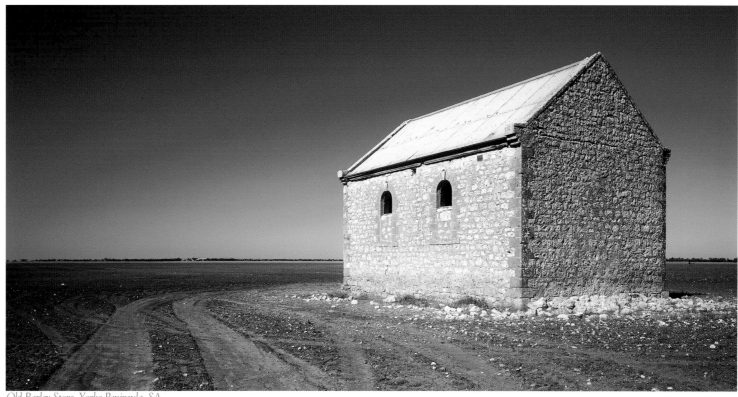

Old Barley Store, Yorke Peninsula, SA

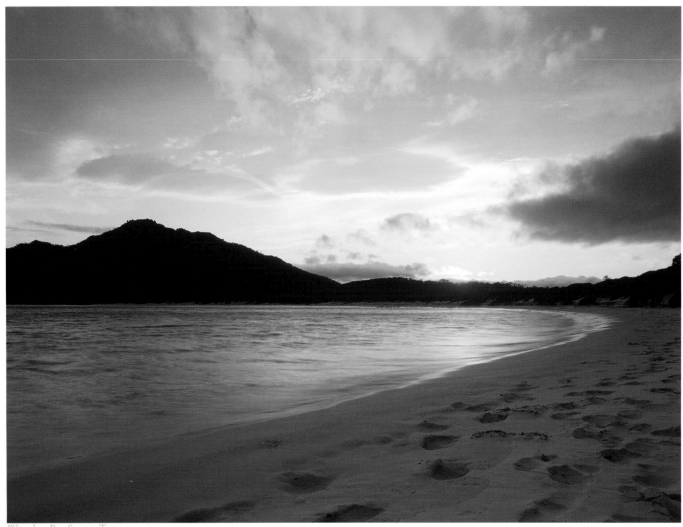

Wineglass Bay Sunset, Tas

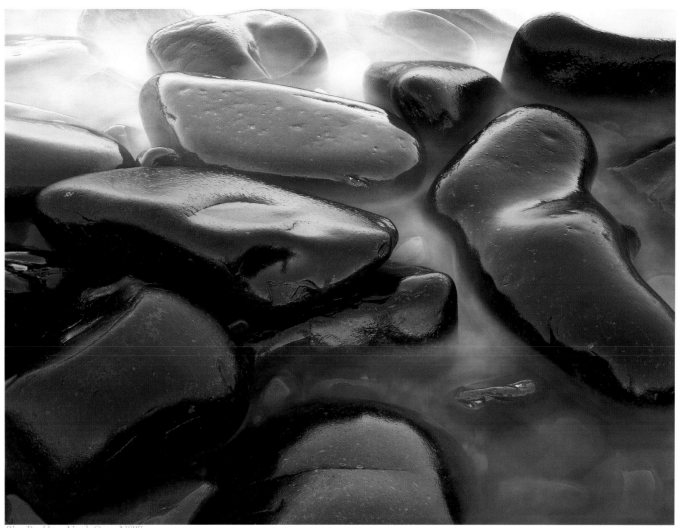

Blue Boulders, North Coast NSW

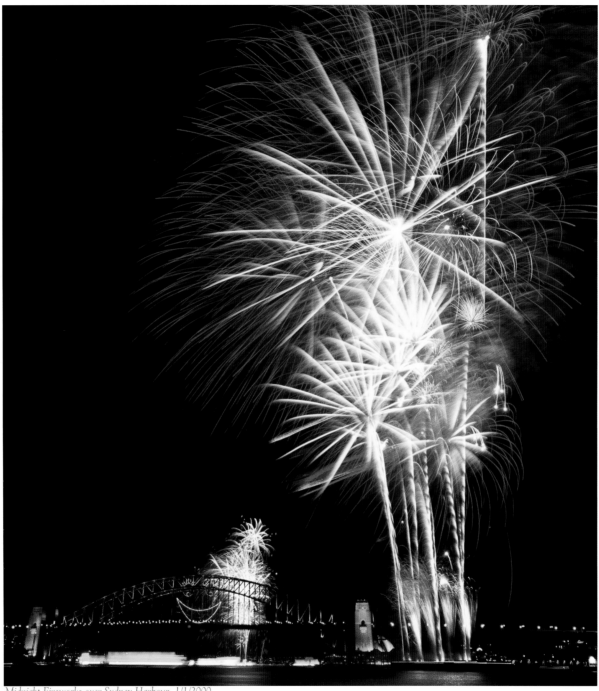

Midnight Fireworks over Sydney Harbour, 1/1/2000

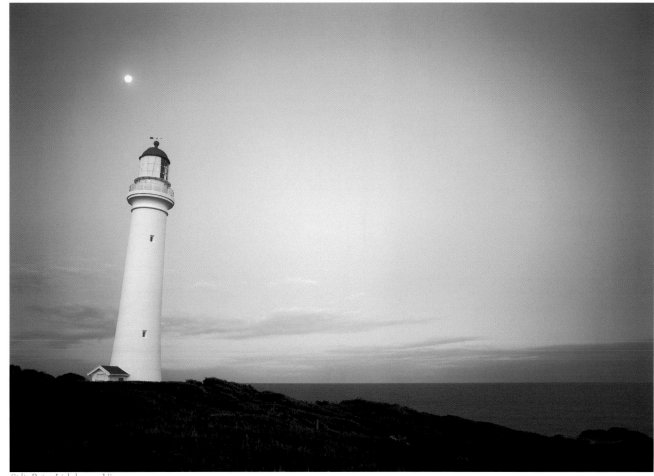

Split Point Lighthouse, Vic

Split Point Lighthouse

*Dust upon his boots from playing with the children in the sand till the afternoon grew
soft and he left them, letting water from the trench. Up he tramps, looking under swollen
eyelids from the windows as he clangs upon the steps. Such a seaman's face is this, black
stubble of an ever-pressing beard and sea-wrought wrinkles; a dirty red handkerchief
round his neck. No stars, just a moon, and that sweet perfection that makes an old
Catholic, far from any church, cross himself as he stands betwixt the winds. Removed
from youth or age is a lighthouse keeper, who must ever hold the sky up with his brows to
keep the dark from pressing on the ships. Yet those children are his, who hear their
mother's voice come, swinging out the loneliness, from the cottage and take their spades
and buckets; little specks that run up blackened grasses. His grim face smiles, lights the
lamp and sends it spinning underneath the clouds.*

Rock Patterns, Coastal NSW

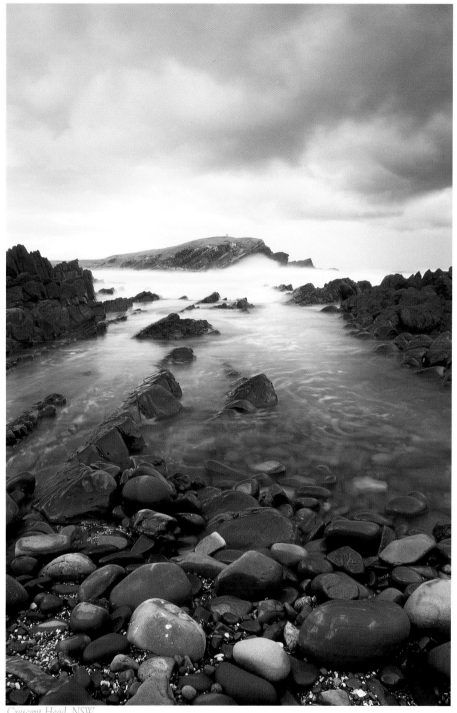

Crescent Head, NSW

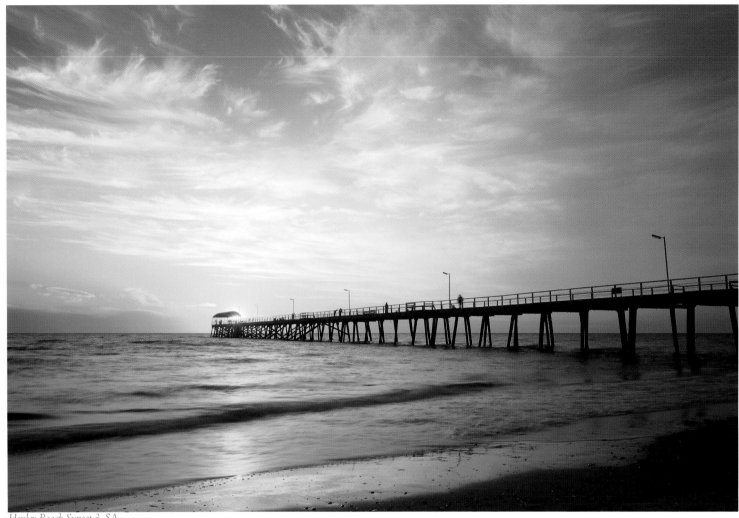

Henley Beach Sunset 3, SA

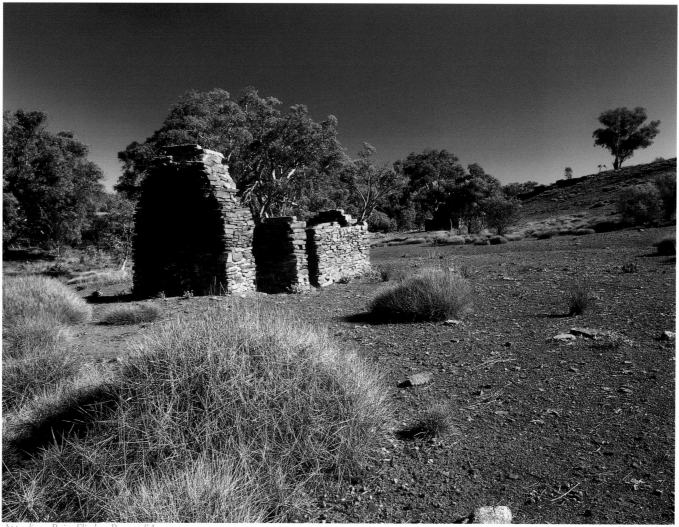

Appealinna Ruin, Flinders Ranges, SA

Appealinna Ruin

The sky is lit by firecrackers, glaring to go off, and the tumbledown old house sings like a
boiling kettle; for the red earth is glowing embers, roared by the bellows; some terrible
blacksmith lives below, I can see his sweat in the shadows.

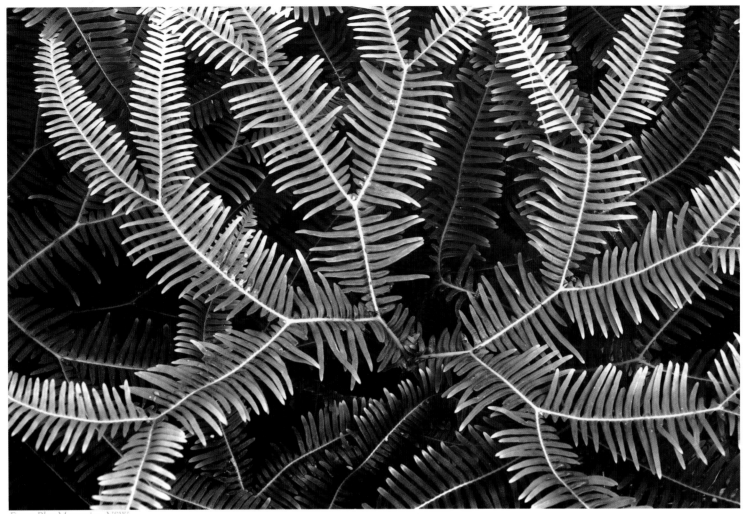

Ferns, Blue Mountains, NSW

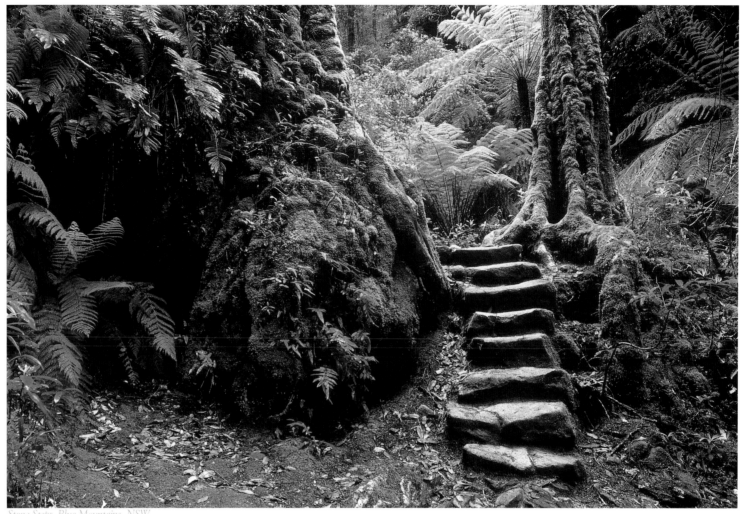

Stone Steps, Blue Mountains, NSW

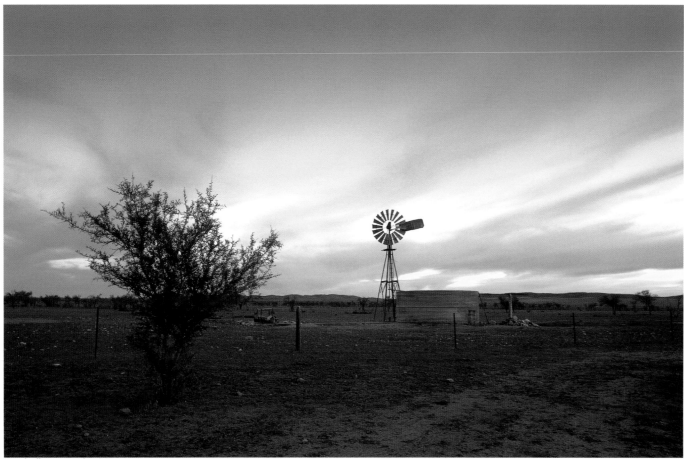

Windmill near Eurelia

*Heat, and the bang of old tin comes rising and falls with the wind, the breath of wind that
shakes, for a moment, the old sticks in the bush. Then ceases.
Dried-up plains flow out from us. There is a billy-cart caught in the dust. The
murmuring clouds give a voice, in the silence, to colours. When the water comes no doubt
this silent life will welcome the rains. But for now all dust is soft and the earth sleeps
indifferent to any fingers that would touch. Even ours.*

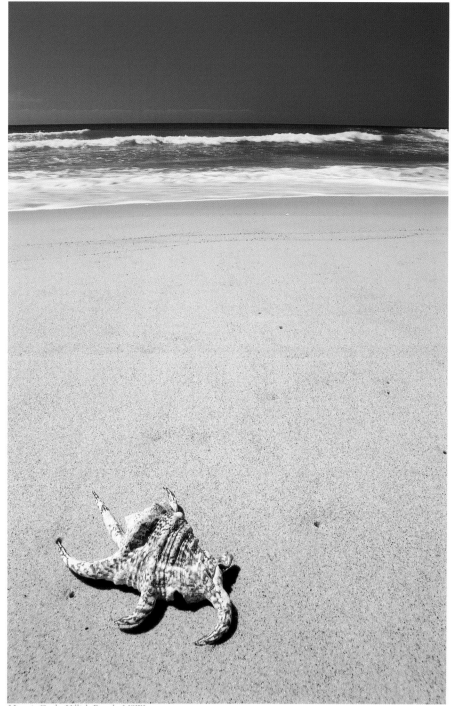

Hermit Crab, Killick Beach, NSW

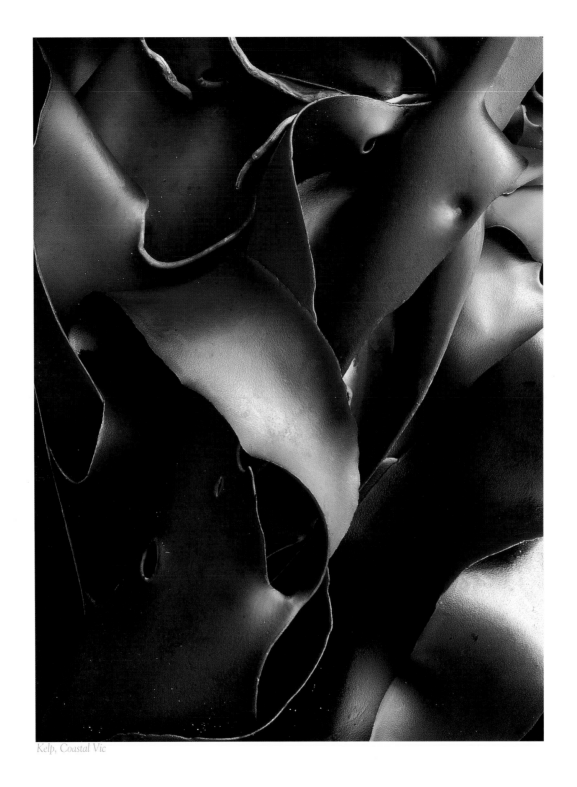

Kelp, Coastal Vic

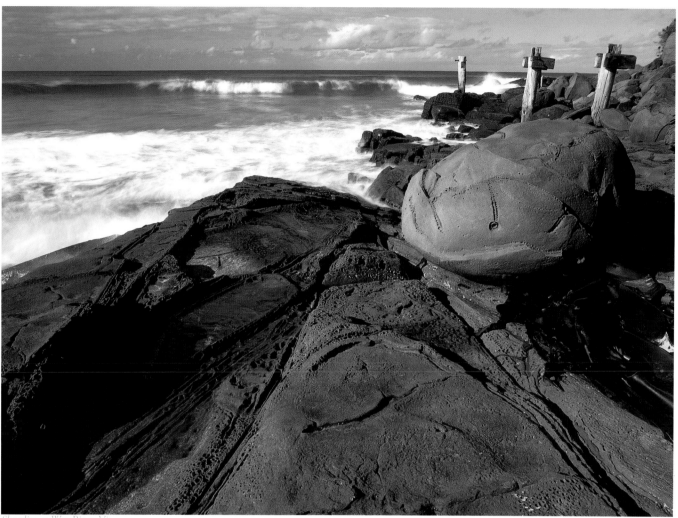

Shoreline at Wye River, Vic

Pomborneit

Of cold snaw
And the winds all writhing,
The frost-bitten face at the window
Wrapped in a scarf of scarlet -
Of this she told,
The old woman
Who sat by the stones of the wall
To rest herself
On her way up the hill.
"An' these trees,
We planted these
When the sun was shinin'
And the rainclouds were all in the West.
They've blossoms,
You will see the blossoms soon
I have no doubt."
"And the woman in the red scarf?" I asked.
"My sister's husband had a daughter.
She came to live with us
When they were both carried off with the Typhus.
They lived in one of them far off places.
She bought that scarf way out
And she would always wear it.
Though I believe it was given to her
By a sweetheart.
She had deep blue eyes
And her face was always white
With pink cheeks, she was so cold."
"And where are you going to now?"
"To my grave, my dear,
Yonder, up on t'hill they had me buried.

Oh I lived here a long time ago
When the farmer's house had a little cart
And they would send me a pony
For each child but the last.
The last had his birth in that copse here,
Under these blossoms,
He came so fast.
Look at the roof and its rust.
It shined so when my husband laid the sheets.
And every brick and's mortar he pasted
With his own hands.
Oh, tush, the wind has all gone now,
See how the grass stands.
'Twill not be long before it rains.
You'd best get under the roof, in the doorway."
"But it is but an outhouse, you did not live here
With all those children?"
"Aye, but I did. Come, come, feel those drops,
I shall be walking again and you must mind yourself."
"But wait, old woman, did she get married -
The woman in the scarf of scarlet?"
"Oh yes! she were the minister's wife,
And a great day that was for us
When we decked the gutt'ring with flowers
And he gave her a white silk dress and pearls.
But dear, I must be off."
And the grass grows flat and waves
As the wind sprays droplets on the tin roof.
I can see her as I peer through the trees
Driving the wind with her ghost.

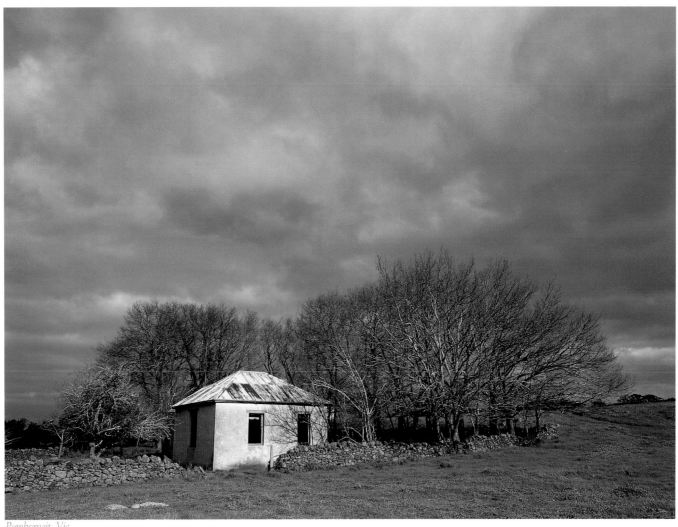

Pomborneit, Vic

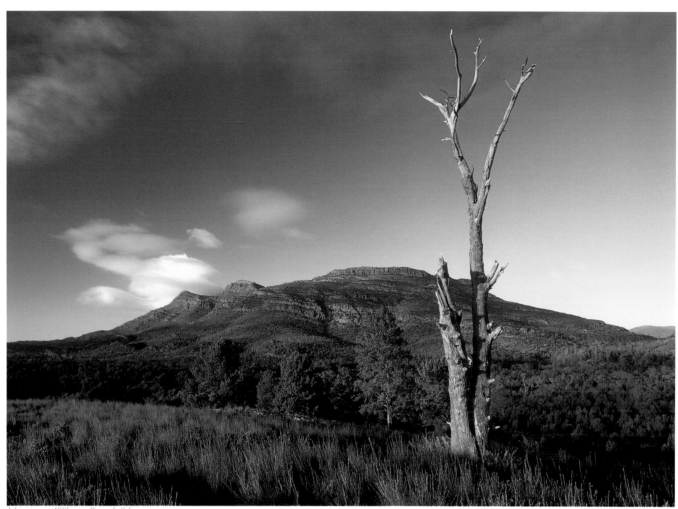

Morning at Wilpena Pound, SA

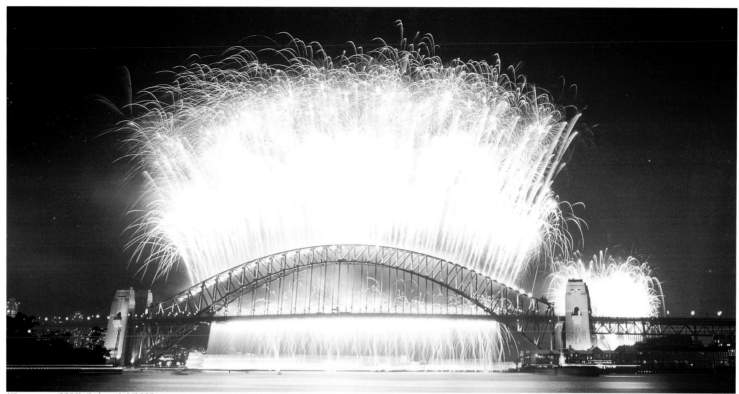

'Gateway to 2000', Sydney 1/1/2000

Images

Poems

Music

The Photographer

Born and raised in Sydney, David Evans now calls Adelaide home. The inspiration for this book stems from his love of the wild, open and majestically beautiful Australian landscape, and the joy of bringing it to others. The bold and spectacular style of David Evans is presented as a visual experience, which creates a longing for the outdoors. David says he is fulfilled when people say "wow", or are simply lost for words after viewing his photography.

David Evans is one of Australia's most dynamic and talented landscape photographers. Being self-taught, David also gains inspiration from the work of others in the field, including Ken Duncan and the late Peter Dombrovskis. His most powerful inspiration, however, is the landscape itself.

"Seeing spectacular locations and being in the outdoors gives me an immense and overwhelming feeling of wellbeing," David says. "This is made more special when I can give others a taste of this feeling I experience, through my photographs."

David's photography is recognised by various prestigious awards, accolades, publications and institutions both in Australia and internationally.

David Evans by Ian Carlson©

Technical Photography Notes (by David Evans)

The images in this book were taken with various cameras and formats, ranging from 35mm to 6 x 4.5 and 6 x 9 medium format, and 6 x 17 panoramic. My favourite camera is a Fuji G617 Professional which provides a beautiful, crisp panoramic frame of 6 x 17cm, allowing for enormous and spectacular enlargements to be printed.

The only colour film I use is Fuji Velvia, unmatched in grain structure, colour depth and saturation, giving vibrancy and a "wow" factor that in my opinion is unrivalled. Agfa, Ilford and Kodak are my preferred brands for B&W film.

All shots were taken using a Manfrotto tripod. My lightmeter is a Gossen Multisix with spot attachment, as the Fuji G617 is a rangefinder with no power source. I prefer, regardless, to take incident, reflected and spot readings by hand.

To take a good photograph does not require the latest and greatest gear, but reliable and quality equipment are essential in producing quality images. After all, the camera is merely a box. The picture comes from the mind and eye of the photographer - with patience.

The Poet

Jennie Sharpe by John Sowden©

"With the sun rising in your face you can only turn and go inwards, and find the very heart of the earth, letting its dirt sift into your fingers."

Jennie Sharpe was born and raised in Sydney. She is a novelist, poet and short story writer. Her poems seek to capture the essence of the landscape and of a personal relationship with the earth. "I wish to draw the reader into their imagination and to display, in story or metaphor, the connection between our emotions and those of the landscape...often merging the two so there is nothing to distinguish between them."

Having travelled through South Australia, Victoria and New South Wales, Jennie has a great love for the Australian countryside. This connection to the beauty of the land, combined with her love of history, music and symbolism, has led her to create song-like, rhythmic poetry, in perfect harmony with the photographs. From the dynamic and vivacious to quiet imagery, her poems follow the changing moods and seasons of the country.

The Composer

Leah Curtis is a composer, conductor and musician. She has found international success and recognition through her music, with performances that include Australia's premiere orchestras and the film music stages of Los Angeles. The Sydney Symphony Orchestra, after performing and recording her music, recognised Curtis as a "dynamic young musician."

The Canberra Times describes her music as having a "sweeping lyrical quality..." and the "...urgency and freshness typical of Australian scores." Curtis has composed and recorded original music for many genres, including concert hall, film, television and theatre.

Leah holds a deep affinity for the Australian bush, where she has spent time exploring national parks and rural properties.

Leah Curtis brings a rich musical life to *Australia: Facing the South*, complementing David's images, Jennie's poetry and the natural soundscapes of Listening Earth.

Her music takes you deep into these unique and diverse Australian landscapes, and has you relish in their exquisite beauty, and contrast.

Leah Curtis©
(www.leahcurtis.com)

australian gallery publishing

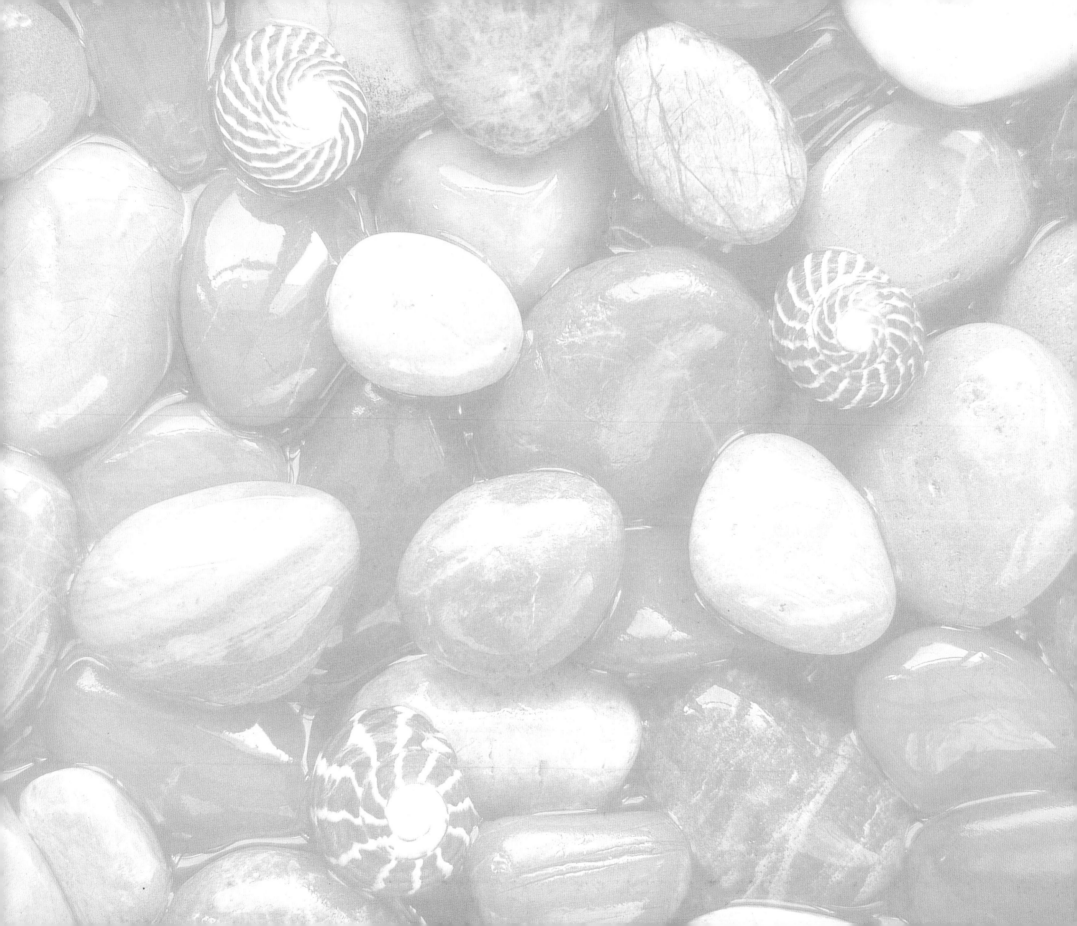